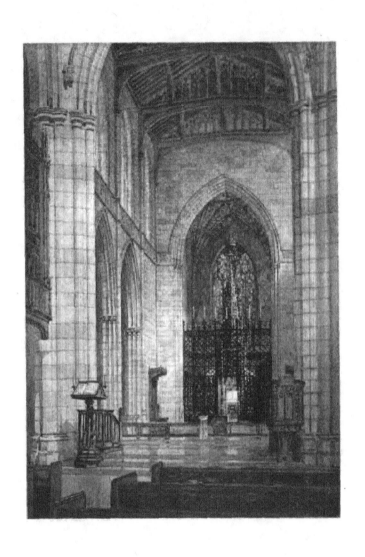

BEYOND ARCHITECTURE

By

A. KINGSLEY PORTER

BOSTON

MARSHALL JONES COMPANY

MDCCCCXVIII

CONTENTS

ILLUSTRATIONS

PRESCRIPT

MISBORN in a time of cosmic up-
heaval, this volume appears an in-
conspicuous baby of peace, whose feeble wail,
notwithstanding the unreasoning vastness of
parental ambitions, is likely to sound more
than ever unavailingly amid the shrapnel and
groans of a great war. Before abandoning it
upon the door-step of that public opinion,
which is so largely responsible for its exist-
ence, I feel impelled to fasten about its neck
something in the nature of a birth certificate,
unnecessary and odious as I hold in general
such documents to be. I hence make formal
avowal that it was conceived in the most re-
spectable possible manner, that is to say, in the
lecture-hall, than which, as is well known,
nothing is more restrained, more chaste, more
completely free from all suspicion, not only of
scandal but even of legitimate pleasure. The
material was subsequently worked over into
a series of articles which eminently respect-
able periodicals were induced to publish —
The Architectural Record took " Against
Roman Architecture " and " Art of the

Middle Age "; the *Journal of the American Institute of Architects,* " Gothic Art, the War and After " and " Paper Architecture "; *Architecture,* " The Gothic Way "; *Art and Archaeology,* " French Gothic and the Italian Renaissance "; *The American Magazine of Art,* " The Art of Giotto " and the *Yale Review* (God help the editor!), " Art and the General." I roll with unction the names of these orthodox sponsors in baptism, for I have a presentiment that this wayward and unconventional infant may have sad need of all the backing it can muster against the powers of banality and Philistinism. In common honesty, however, I must add a confession. One day I became aware, quite to my own surprise, that these articles were something more than a series of detached essays, that collectively they formed an outline — fragmentary it is true, but still not entirely without coherence — of a new system of architectural criticism. I consequently determined to gather them together to form a little book. This gave me the opportunity — and I come now to the point—of making many changes in the original versions. As the copy at present stands, there is no telling whether anyone would print it, except Mr. Jones, who, as everyone knows, through having

PRESCRIPT

served the public in Mr. Cram's *Gothic Substance,* delicious but forbidden fruit, has no longer left to lose even the shred of an orthodox architectural reputation.

BEYOND ARCHITECTURE

AGAINST ROMAN ARCHITECTURE

IN the course of an article published in the *Architectural Record* some months ago, my old teacher, Professor Hamlin, quoted with disapproval certain criticisms of Roman art from my youthful work on *Mediæval Architecture*. That the ideas in question are such as might readily find no favour with Professor Hamlin does not surprise me. It is entirely orthodox to admire Roman architecture. Of all historic styles it presents the closest analogies with the architecture of the nineteenth century in America. It is the style upon which our modern architectural education is based. It is also, of all historic styles, evidently the least illustrative, the most material. Something over a decade ago, I came to the rather impulsive conclusion that the thoughtless admiration and imitation of the Roman style was producing a deleterious effect upon contemporary American art. In

[1]

writing my *Mediæval Architecture* I felt it almost a duty to do what I could to call attention to the prosaic character of the Roman style.

The difference of opinion between Professor Hamlin and myself is, therefore, deepseated. *De gustibus non est disputandum.* In matters of this sort there is no absolute proof to which one can have recourse. It is a question of feeling — really of creed — and as differences of religion are commonly the ones to which men cling most tenaciously, for which they are ready to sacrifice themselves and wrong others, so for the lover of art his æsthetic creed is, perhaps, the most deeply rooted part of his inner being, that which touches him most nearly when questioned by another.

The years that have passed since I wrote *Mediæval Architecture* have brought changes in my point of view. Further study has proved to me that the deficiencies of contemporary art cannot altogether be laid at the door of Rome. I have remarked that, inspired by the same models, Palladio produced an architecture highly intellectual and McIntire an art infinitely refined. Very poor indeed, has been much of the architecture imitated from the most exalted models of Greece and

of the Middle Ages. The conclusion seems
to be forced that for the production of good
architecture it matters little *what* one copies,
but it matters very vitally *how*.

As for Roman architecture itself, I have
come to know it much better since the days
when my first book was written. At that time
my lips had barely touched the golden cup of
Italian beauty. Since, the opportunity has
come to linger long in Rome; to draw and
photograph among the ruins of the Agro, to
poetize with Carducci on the Aventine or in
the Baths of Caracalla. Often as I have stood
in the august presence of the Roman Forum,
it has never been without emotion. I have
studied, with a feeling almost of home-
sickness, the engravings of the eighteenth
century, stimulating my imagination to con-
ceive of the City enhanced by the solitude
and silence the modern age so discordantly
breaks.

Yet I cannot with intellectual integrity say
that my feelings towards Roman architecture
have essentially changed in these twelve years.
Visions of the magic of Rome, the cypresses
of Tivoli, the sweeping lines of the Campagna,
the snow-capped encircling mountains, the
glorious colour of the weathered brickwork
haunt my memory; yet I still see in Roman

[3]

architecture, as I did a decade ago, emptiness, pomposity, vulgarity.

But very little of ancient Rome has come down to us intact. The charm which invests the Baths of Caracalla or the ruins of the Palatine to-day was assuredly never dreamed of by the builders. The picturesque masses, the colours, are the work of time — the most clever of artists. To conceive of these Roman buildings as they were, we must have recourse to archæology and modern restorations on paper. But do these imaginary reconstructions give an accurate idea of the æsthetic effect of the architecture as it really was? May we not have missed some touch which possibly redeemed the lack of refinement? Imagine that all the scores of Wagner's Niebelungen Trilogy had been lost, and that some inferior musician should try to rewrite the work on the basis merely of the plot and a few snatches of melody. The result might easily be as meretricious as the restorations of Roman ruins. How can we prove that something like this may not have happened in the case of Rome? When we contrast the actual beauty of the ruins of the Forum with the monotony of the paper restorations, when we note in the latter the lack of balance in the mass and the excessive symmetry in the de-

tails, how can we be certain that the ancient
buildings may not have possessed some secret
of beauty, some use of colour or of asymmetry
unknown to modern archæologists but which
redeemed a design that, only because of our
lack of knowledge, seems lifeless and banal?

Future investigations may possibly show
that Roman architecture was not as dull as it
now appears. I fear, however, that this is ex-
ceedingly unlikely. The frescos of Pompeii
quickly dispel any illusion that the Romans
possessed a sense of colour. An abundance of
Roman architectural detail has come down to
us in good condition; and this, with very rare
exceptions, is not such as to lead us to suppose
that the Romans possessed sensitive æsthetic
perceptions in architectural art. Poor detail
is not necessarily incompatible with good
architecture (although the modern idea that
good architecture must necessarily have bad
detail is obviously false); nevertheless, the de-
tail is apt to be eloquent of the spirit of the
whole. When we find detail that is made
commercially, mechanically, thoughtlessly,
perfunctorily, we have the work, not of an
artist but of a materialist, and the larger
features of the design are nearly certain to be
permeated by the same qualities. The true
artist may delight in the broad effect; he

[5]

may take pleasure in producing that effect in simple materials, but he can never be satisfied with commercial detail. It is this lack of sensitiveness in Roman architecture, the absense of an artistic conscience, the readiness to subordinate all means to the end of an immediate effect, the obviousness, the lack of depth, with which I quarrel. There are two kinds of architecture, as there are two kinds of painting, of sculpture, and of literature. One is artistic, created for the joy of bringing into the world a beautiful thing — material compensation may or may not be given, but is secondary; the other is commercial, made primarily for expediency, for money, for fame. Roman art is of the commercial variety. Of that poetry which breathes so potently from the existing ruins, the same monuments, when new, must have been singularly deprived. They were opportunist structures, lacking in intellectual and emotional content.

There is a curious parallelism between the art, the literature and the life of Imperial Rome. I experience the same sensation of inexpressible weariness in studying Roman architecture and in reading of Roman banquets, as, to cite one example among many, in the *Satyricon* of Petronius. What a bore these

feasts, this endless over-eating and over-drink-
ing must have been! How useless the mag-
nificence, the throngs of slaves, the expert
cooks able to prepare pork so that the entire
company mistook it for duck! As Mr. Clapp
renders Palazzeschi:

> With luxury's glamour
> the table is spread.
> Exuberant flowers,
> gold vases and silver. . . .
> The dishes before them
> Change hurriedly ever;
> soups steaming and purées
> delicious and pâtés
> most tasty by thousands: . . .
> From gardens forbidden
> herbs skilfully seasoned,
> woodcock and pheasant
> pass by in the dishes
> of these the unhappy;
> most tender of green things
> and sweetmeats the rarest;
> incredible sweetmeats,
> fruits red as a ruby,
> wines too of all colours. . . .

All this effort, this expense of energy, failed
of its purpose because there was lacking the
spirit of joy. I suspect that the modern *con-
tadino* takes far greater delight in his *pasta*
and wine in the *osteria* that nestles among the
ruins of the Palatine, perhaps on the very site
of the golden house where Trimalchio gloried
and drank deep. It is evident that the Ro-
mans themselves grew tired of the unending

[7]

series of gluttonous revels. Petronius doubt-
less exaggerates the grossness and stupidity of
Roman society; he, nevertheless, was an eye-
witness to its excesses, and his testimony
carries weight. This is how he describes an
episode at a banquet, when the fatuous Tri-
malchio calls his architect (*lapidarius*) Ha-
binnas and orders his tomb:

"Trimalchio then ordered a copy of his will
to be brought, and this he read from end to
end, while the whole company heaved sighs.
Then looking at Habinnas, he said, ' How
about it, my friend? Have you built my tomb
as I ordered? I ask you particularly to put
at the foot of my statue my little dog, crowns
and a box of perfumery. . . . Moreover let
the tomb measure one hundred by two hun-
dred feet; and let there be planted about it
all sorts of fruit-trees and many vines, for it
would be absurd that I should be said to have
cultivated my lands while I lived; but neg-
lected those where I must inhabit so long.
Therefore I should like to have this inscrip-
tion placed on the tomb:

> *This Monument does not belong*
> *to my Heirs.*

' Furthermore, I shall take care in my will
that no one injures me after my death; for I

[8]

shall appoint one of my freedmen to guard my tomb, to see that no one commits there any nuisance. I charge you also, Habinnas, to sculpture on my tomb ships under full sail [this in reference to the source of Trimalchio's wealth], and my portrait is to show me sitting on a tribunal with five golden rings on my fingers, giving silver coins to the populace out of a sack; for you know well I have given a public banquet and two pieces of money to all who came. You may therefore also represent, if you please, the dining-hall and all the people eating with pleasure. At my right you will place a statue of my wife, Fortunata, holding a dove in one hand and leading a dog on a leash with the other, and you will put there also my dear Cicaron and great jars of wine well corked up. One only of these shall be broken, and a child shall be weeping over it. In the middle of the sundial shall be an inscription so placed that any one reading the hour must perforce see my name. As for the epitaph, see if you think this is suitable:

*Caius Pompeius Trimalchio, the Patron of
Art rests here. He never wished to hear
the Discourse of Philosophers. May thou
do the same. . . .*

[9]

'Thanks to Mercury, I have built this palace of mine in which we now are; as you know, it was a house, but now it is imposing as a temple; it has four drawing-rooms, twenty bed-chambers, two marble porticoes, a tower above in which I myself sleep, apartments for my wife, an excellent porter's lodge and slave quarters able to accommodate a thousand persons.' "

The satirist has painted for us most admirably the spirit, not only of Imperial Roman society but of Imperial Roman art. Indeed, of the inferiority of that art Petronius himself is well aware. Farther on in the same satire he explicitly complains:

"The fine arts have perished, and especially painting has left of itself only the least traces. We do not create art, but only criticize that of antiquity (i. e., Greece)."

It would obviously be untrue to maintain that all Roman architecture lacks artistic vitality. Probably no generality is ever strictly true. The stucco reliefs of certain tombs on the Via Latina were modelled by a man or men who felt beauty, and who were singularly successful in transmitting that impression by a few powerful strokes on the wet plaster. Occasionally, in the carved ornament, as in the arch of St.-Remi, a real artist showed

what life could be given to a traditional
motive. Such flashes, however, only deepen
the general impression of perfunctoriness in
Roman work. Notwithstanding the variety
of type, the skill in planning and engineering,
the varied materials, the colossal scale (per-
haps even because of the latter), the art as a
whole is joyless, like a painful task performed
more or less conscientiously, without enthusi-
asm. One feels intuitively that the builders
cared little for the selfish Cæsars in whose
honour they erected triumphal arches and
palaces; that they cared little for the popu-
lace to shelter whom they built unending
colonnades on the streets and forums, and least
of all for the temples to strange, cold gods.
The yoke of the taskmaster lies heavy upon
their arm, as it lies upon the arm of a worker
in the modern factory.

It is by this token, perhaps, that the failure
of Roman architecture is most clearly proved.
For the essence of all great art is joy: the joy
of grandeur, the joy of poetry, the joy of
gloom, the joy of tears perhaps, but always
joy. The genius imbues the object of his art
with a spark of this divine joy, so that it
may awaken in others the same, or a kindred,
emotion. Many may feel such emotion with-
out the ability to express it; many may have

the ability for expression without feeling the joy to communicate. Such will endeavour in vain to simulate or force an emotion which is not genuine. They may succeed in deluding even the keenest critics for a while, but the eternal difference in value abides unchanged, unchangeable. If there be not joy in creation, all is in vain.

The truth of this may be illustrated in a sister art. If the *Virgin of the Rocks* at London were an original by Leonardo da Vinci, its importance would be incalculable. If it is a copy of Leonardo's painting by his pupil, Ambrogio da Predis, all the world will esteem it much less. In either case the picture is intrinsically the same. The keenest critics have been proved quite capable of mistaking the copy for the original. Is the original prized and the copy depreciated because we are such fools as to be guided in our artistic preferences by a name? I think not. The Paris original possesses an intrinsic value which the London copy lacks. The absoluteness of this value continues none the less to exist, even if it be mistaken by critics who happen to have gone astray. The value of an original lies in the fact that it communicates to us directly the conception — the impression of joy — of the creator; whereas in a copy the

impression is almost necessarily blunted by transmission through another hand.

I have often heard architects, in speaking of some *projet,* use the phrase, " great fun." In fact, the words have almost become current architectural slang. They are vastly significant. They express simply, and without pretention, that joy which is equalled by no other, the joy of creative work. The element of joyousness is thus not altogether lacking in our modern architecture. It is to be regretted that it does not more often extend downward from the architect to his office force, and that it is frequently crushed out entirely by the combined forces of steam heat, plumbing and labour unions.

There remains, it is true, a deep mystery in Roman architecture. If we grant that it is lacking in the spirit of joyousness, and that joy is the essence of great art, how are we to explain the admiration, the adulation, that for centuries have been heaped upon the Roman style? It is necessary, first of all, to concede that it is no new thing for artists, and even for critics, to mistake a crow for a swan. The vogue of the eclectic painters, whose art is so closely akin to that of ancient Rome, lasted until yesterday. Perhaps we have already touched upon the inner essence of the matter

in discussing the relative values of original
and copy, and the necessary inferiority of
the latter. Roman art is a copy, a free
copy with variations, but still a copy. For
long centuries, the original remained un-
known. It was unsuspected that Roman
architecture was a copy. Men praised
it for a beauty it possessed only at second
hand. Winckelmann set the modern world
upon the track of discovering the original.
When Greek architecture had once been
brought to light, the inferiority of the Roman
replica became manifest. It was at once
clear, and recognized by architects, critics
and public alike (at least in America), that
the spirit of joy, of enthusiasm, of poetry, was
present in Greek work, and that Roman
architecture possessed these qualities only by
reflection. There ensued the Greek revival.
However, a little knowledge proved a danger-
ous thing; modern architecture imitated from
the imperfectly comprehended Greek was
seen to be less successful than that inspired by
the more tangible Roman style. Hence the
profession sought to reinstate the sadly shat-
tered idol on her paper throne.

Furthermore, in accounting for the popu-
larity of Roman architecture, we must con-
stantly bear in mind that the art exists only in

imagination. Each person has had to reconstruct his own visual image of the appearance of the buildings. Former centuries did not possess our prosaic archæological information. Inspired by the beauty of the ruins, a Piranesi might imagine Roman art fired with an originality, a joyousness, which the Romans never knew. Many architects, notably our own Thomas Jefferson, have done precisely this. Thus the shade of Rome was shrouded with phantom glory.

From what has been said, I think, it will be evident that I must continue to differ from Professor Hamlin on the question of Roman art. What I felt instinctively, intuitively, as a boy, has been confirmed by the most careful study and thought of which I am capable. I believe, and I believe deeply, in Greek, Romanesque and Gothic. I believe in the Italian Quattrocento, and the American Colonial, even in the Barocco, if you will, but I refuse to bow down before the Goddess Rome.

ART OF THE MIDDLE AGE

THE touchstone of art is intellectuality. If we consider the evolution of man from the savage beast, we shall see that the art which he produces possesses permanent artistic value in measure as, in the progress from brutality, man achieves intellectuality and reflects this in his handicraft. Animals have no art. As man has evolved, he has gradually attained the mentality necessary for artistic production. It is true that the quality of intellect required for attaining success in art is very different from that required for attaining success in other lines of human activity. Thus it has come about that primitive peoples have at times produced greater art than races commonly accounted more civilized — a fact which in no wise disproves the general truth that art can only be created by brains, brains of a special type, but still brains. The collective mentality of a tribe may enter into the creation of folk art and may prove itself the equal or superior of any single intellect of a later stage of development. It is none the less intellect. If the progress of the artistic sense has not been

steady, if it has advanced rapidly to recede subsequently, it is only displaying a phenomenon constant in all evolution. Many forms of art require in addition to mentality technical dexterity, but the latter is in reality merely a means of expression for the former, bearing to it the same relationship that printing does to a book. Unless there be the conception, the emotion of beauty, dexterity of hand is of no avail. If we seek to-day the primary difference between a symphony by Beethoven and a "coon song," between a drama by Shakespeare and a play by Cohen, between a painting by Botticelli and an illustration in one of our comic weeklies, we shall find that, in each case, what is great and what is enduring differs from what is perishable and of no account by the element of intellectuality. It is, therefore, in the scale of intellectuality that the value of any work of art must be weighed.

By modern architects one not infrequently hears the sentiment expressed that intellectuality in a building is a comparatively minor consideration, and that the really important matter is beauty (by which they mean what I mean by *joy*) as expressed in line, rhythm, proportion, mass, colour and so forth. That is to say, beauty and intellectuality are con-

sidered divisible and even antagonistic. A
strange misconception! The sense for beauty
is obviously an attribute of the human mind,
merely one phase of intellectuality, nothing
less, nothing more. It requires an intellectual
effort and intellectual training to achieve, as
to appreciate, proportion or mass or line or
rhythm or colour, and it is precisely accord-
ing to whether a modern building achieves
or fails to achieve these elements of intellec-
tuality that is is judged good or bad. Of such
formal beauty I shall say little, because being
common to the best architectural achieve-
ments of all ages, it is generally recognized.
No one will, I think, claim that formal beauty
is lacking in mediæval architecture. In
classic art we shall hardly find a façade as
happily proportioned as that of Paris; we
shall hardly find more effective massing than
in the spires of Normandy; we shall hardly
find line used to greater advantage than in the
portals of Reims; we shall hardly find finer
rhythm than in the interior of Amiens; and
we shall certainly not find colour as impres-
sive as that of the glass of Chartres. It is not
at the expense of, but in addition to, these
formal elements of beauty or intellectuality
that Gothic architecture achieves also others
of an even higher order.

There are many kinds of intellectuality. Although most modern and Renaissance struc‑ tures — in fact, it is not too much to say all — lack the great intellectual qualities of the buildings of the Middle Ages, they obviously may, nevertheless, be of high merit. A design which, from many points of view, is utterly illogical and absurd, violating many canons, not only of intellectuality but of common sense, like the Palazzo del Consiglio at Verona, may still possess other intellectual qualities — such as delicacy, rhythm and colour — that justly entitle it to admiration. Similarly (although I should not wish to be understood as ranking the two buildings together) the Old Library in New Haven, notwithstanding very evident offenses against reason, still manages to achieve by means of its proportions and rhythm, the softening of age and vines, a beauty which entitles it to rank among the best buildings of the Gothic revival in America. Such edifices amply demonstrate that it is possible for architecture to rise considerably with the aid of a limited intellectuality — flying on one wing, as it were. It is only, however, when all her feathers of intellectuality are fully grown that architecture can reach the greatest heights. A little intellectuality is better than none, but

the greater the intellectuality the greater the architecture. Gothic is incomparably the most intellectual of all architectures.

Works of art are great in measure as they possess the quality of inexhaustibility. The obvious may captivate at first glance, but is incapable of bestowing an abiding satisfaction. Close and continued familiarity will, except with shallow natures, inevitably breed contempt for the meretricious. In art, as in all else, we take out as we put in. That which forces itself upon us, the pleasure which we acquire without expense of effort, will not endure. Here perhaps lies the final proof of the worth of mediæval art. For no other style requires as great preparation on the part of him who would enjoy; nor is there any which extends such rich rewards to the happy initiate.

Together with the fundamental fact of criticism that architecture is good or bad according as it is intellectual, we must take into consideration two facts of actuality, which, at first glance, seem so opposed to the usual twentieth-century way of looking at things that they appear paradoxical, but which, nevertheless, if we stop to consider a moment, are both evidently true. The first of these facts is, that the thirteenth century

was a time of extraordinary intellectual development, and the second fact is, that the modern age, from certain points of view, is a time of intellectual degeneration. We are so in the habit of dwelling complacently upon the railroads, electric apparatus, machines, plumbing and other similar physical luxuries which we possess, and which obviously the Middle Ages did not possess, that we have blinded ourselves to the equally evident fact that this material progress has been accompanied by, and in a sense bought at the price of, the deterioration of several mental faculties. In the last few years, modern thought has made a great advance in returning to the Middle Ages. By certain scholars the thirteenth has been pronounced the greatest of centuries. 'Superlatives are dangerous; but it is an undoubted fact that the result of recent research has been to increase more and more our admiration for the achievements of the Gothic period, not only in the realm of art but also in the realm of pure thought.' The very intellectual superiority of the Middle Ages was, in a way, the reason which led the Renaissance centuries to despise not only mediæval art but mediæval philosophy. We moderns are eminently lazy, and our speculation always has primarily a practical or util-

itarian scope. We seldom think anything out
simply for the joy of the thinking. If we
wrestle with an intellectual problem, it is in
order that we may attain thereby some ma-
terial end. The Middle Ages, on the other
hand, loved thought for its own sake. They
wrestled with intellectual problems for the
mere delight of overcoming them. It hence
came about that the mediæval thinkers arrived
at results often of great æsthetic beauty, but
which seldom were of practical value. Mod-
ern speculators, who cared entirely for the
material, set aside mediæval thought because
they found that it was not useful in enabling
them to improve the mechanical arts, or to
make new discoveries along practical lines.
Being entirely absorbed in the solution of
pragmatic problems, they chose to devote no
energy to comprehending the purely specula-
tive turns of mediæval thought. In the last
few years, however, we have begun to realize
that this scorn of the modern for mediæval
philosophy was very largely the scorn of the
barbarian who stood before the Greek marble,
and considered it valuable only for burning
in the kiln to produce lime. It has begun to
be perceived that mediæval thought was ex-
ceedingly beautiful, exceedingly subtle, ex-
ceedingly profound; that, in short, modern

thinkers, in rejecting this immaterial and absolute speculation, have rejected something that the world is very much the worse off for not having. Mediæval thought may be compared to pure mathematics. The mathematician who follows his speculation in the solution of problems which can have no practical or utilitarian result — at least directly — and is yet so carried away by his intellectual curiosity that he gives his time and his genius lavishly to their solution, is the nearest approach in our age to the mediæval thinker. It is almost inconceivable to us that mental gymnastics could have been enjoyed to such an extent and for their own sake. We, who shrink from every mental exertion, and can be spurred to mental activity only by the prods of our comfort or our pocket-books, cannot understand the overflowing energy of the mediæval genius, its delight in intellectuality for its own sake, its scorn of the easy and the obvious, its love for the subtle. Yet the mediæval mind, in a way, is as superior to ours as a spirited stallion is to a dray horse. By means of its exuberant, almost wasteful energy, it achieved results of which we are incapable.

Mediæval art is the faithful reflection of the mediæval mind in its intellectuality, in

its subtlety, in its avoidance of the obvious. Like mediæval thought, it was long held in scorn and derision by later ages which were unable to fathom its profundity. Notwithstanding the increased appreciation of modern times, the vital beauties of the Gothic cathedral still roll by far above the head, not only of the average layman, but also of the average architect.

A curious example of the modern lack of comprehension of the Middle Ages, and of the modern tendency to scorn everything which it cannot understand, is afforded by the history of the researches of Mr. Goodyear. This archæologist stated that mediæval buildings were not built upon straight lines as modern buildings are. It was a question of a fact found in practically all mediæval buildings, to be easily demonstrated and tested, even by a casual inspection. Mr. Goodyear's announcement was at first greeted with incredulity, and no one was more incredulous than the archæologists and the architects. In modern buildings the T-square and triangle rule supreme, all lines are straight, hard and metallic. It was therefore unthinkable to the modern architect that there could be any other way of building. Yet the mediæval method of construction was in-

finitely more subtle, infinitely more intellectual. For the obviousness of regular spacing, it introduced the subtlety of spacing which was not quite regular. For the obviousness of straight hard lines, it substituted the refinement of lines which were not straight and not hard. For the obviousness of something taken in and comprehended at a glance, it introduced something so subtle and illusive that its very existence was lost sight of for long centuries.

The same principle of variation is carried out in every detail of the Gothic structure. In a classical building, all the capitals of an order are precisely the same. One model serves for the lot. It is impossible to distinguish one from the other. Gothic builders would never do anything so banal. They made each capital different. Each has something new to say. The attentive observer will find in each a new design, a fresh beauty. Take a large building such as a cathedral, which undoubtedly contains hundreds and probably thousands of capitals. The intellectual appeal afforded by mediæval art, where each of these capitals was a source of an intellectual demand upon its creator, and where each one affords an intellectual delight to the observer, is infinitely greater than in a

[25]

classical building, where every capital is like every other, and where all are designed according to a well established and immovable norm. Yet I do not think that the classic order, repeated thoughtlessly, almost mechanically, so many thousands and millions of times, at its very best was absolutely more beautiful, better studied, more thoughtfully worked out, than a French capital of the twelfth century, which was a new and original creation forever unique.

It is not only in the capitals that the mediæval building possesses this greater wealth of creative imagination. The same details are never repeated. Each moulding is varied. The mediæval cathedral is never obvious. Its choicest delights are reserved for those who study it patiently and long. Even the grotesques, which at first sight seem so naïve and simple that the word intellectuality can hardly be applied to anything so immediately appealing, are, in reality, extremely subtle. These strange creatures are infinitely varied among themselves, unlike the grotesques on a classical building, where, for example, the same lion-head is repeated many times. The mediæval grotesques, as wild and elusive as the bats and rooks in whose company they spend their existence,

are endowed with the fascination and mystery of untamed things. They are finer grained, more sensitive than classic grotesques, just as the wild flower possesses a poetry lacking in cultivated blossoms. They reveal the intellectual thirst of the Middle Ages, the insatiable longing of the men of that time to know what might be contained in unexplored portions of the universe. For in those days men lusted feverishly, unreasoningly after knowledge. Where means of accurate information were lacking, they, just as we to-day, resorted to conjecture and imagination, with, however, the difference that their imagination was infinitely finer and more poetic than ours. The intense interest excited by the bestiaries is to be explained on this ground. The strange and romantic animals there described are largely those which are not found in Europe, and the Middle Age brooded long and thoughtfully over the marvellous characteristics of these fabulous beings of distant continents. The grotesques seem to be merely another flight of the mediæval imagination in its efforts to conjecture what the fauna of unknown countries might be like. The Gothic artists set themselves no meaner task than to represent in the cathedral everything which exists in the universe. The Church was the

reflection of the supreme goodness of God, as shown in the work of His hands. As such, it was fitting that the animals of the world should be represented alongside the other manifestations of divine wisdom.

From an artistic point of view, these lighter and more fanciful figures serve as a contrast to the profound and mysterious imagery which elsewhere adorns the cathedral. Like a burst of childish laughter they relieve the gravity of the long lines of saints, the soberness of the symbols of man's sin and redemption.

A classical building (unless it chance to be Greek) is understood at a glance. We may take the Pantheon as an example. There is one great dome, the portico before it, niches, and a certain amount of stereotyped decoration repeated with variations. One look at this building reveals to the educated eye all there is. The proportions, the rhythm, the grandiose conception, the simplicity, the undeniable greatness and beauty are at once comprehended. They are so evident that one would have to be stupid indeed to miss them. The consequence is that the Pantheon always has, and always will, appeal to the superficial. Gothic architecture, on the other hand, is infinitely more subtle. The very fact that the

Pantheon contains one large vault, whereas the Gothic church contains ten or twelve or more, makes the classical building much easier to comprehend. The mind catches at a glance the outline and shape of the structure. It is impossible to forget that there is just one dome in the Pantheon, whereas even one who knows Amiens intimately would be unable to tell off-hand how many vaults there are or how many bays the nave is long. The mediæval conception is more subtle, less obvious. Also the details of a classical building, however exquisite, are easily comprehended; those of a mediæval building cannot be completely understood after years of study. Nothing is placed in a Roman or modern building where it does not immediately catch the eye and show. The Gothic building, on the other hand, is full of exquisite detail lavished upon the roofs and cornices, in places where it is necessary to seek with the greatest perseverance to find it. It is natural that the intellectually degenerate modern age should prefer the classical building, and that modern architecture should be modelled upon it. We who are too lazy — as the existence of advertising proves — even to make the intellectual effort necessary to decide which kind of breakfast food it is best for us to use, but

have to have the poorer kind thrust down our throats by means of electric signs and glaring bill-boards, which we, the consumers, cheerfully pay for rather than make the mental effort necessary to decide what we want — we naturally prefer architecture that is built upon the principle of advertising, and that proclaims any merits it may have with such insistence that they cannot be missed. In fact, in modern American buildings, one will generally seek in vain for subtlety of thought or detail. Everything is obvious, pounded forth with a brass band, brandished in our faces. Our style is actually, as well as historically, exhibition architecture, with all of vulgarity that the word implies.

The Gothic architects, for all their interest in detail, were too wise to confuse their general design. In the façade of Reims, for example, there was absolute unity of composition. The broad masses of the buttresses, the form of the towers, the stories were marked as clearly as in a modern construction. The big divisions were not obscured by the profusion of detail. Yet the quantity and quality of the detail was incredible. Each capital, each statue, each bit of tracery, each moulding, was a masterpiece. The delight which this façade gave was therefore much

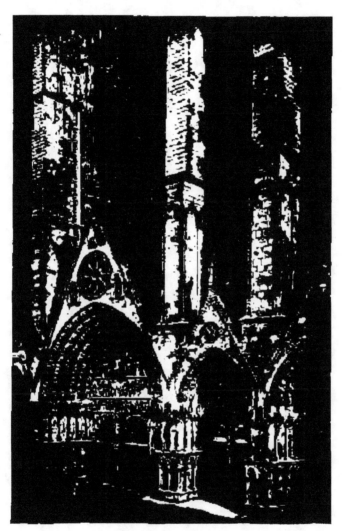

Cathedral at Bourges

greater than that which a modern building is capable of bestowing. We had not only the first joy in the main lines of the composition (such as we might conceivably receive from a modern structure), but the longer we remained the greater became our delight in the details, the existence of which was at first hardly perceived.

The Gothic builders applied the same principle to stained glass, which offers a striking example of the difference in spirit between mediæval and modern art. The mediæval artists made of their glass primarily an architectural accessory. When we first enter a Gothic church, we see in the windows merely a mass of colour, the most exquisite imaginable colour. We distinguish no figures, we see no pictures. It is only when we approach closer that we see each of these windows forms an ornamental pattern of small medallions, and that each of these medallions contains a number of small figures. We have to look with attention to perceive them. When we do give this attention, however, we find that the pictorial design is worthy of the most careful study. Not only are the subjects represented full of profound philosophical and theological meaning, but the flow of line, the rhythm, the composition, and, above all, the

colouring, are sources of unending delight. I have heard modern critics reproach mediæval glass for not being naturalistic. They find fault with the figures because they are not lifelike. Nothing could be more characteristic of the nineteenth century attitude towards art. Some wit has defined modern architecture as that art which makes something constructed of one material look as though it were constructed of another, which, were it genuine, would be objectionable. Modern architects, consequently, instead of being content to let stained glass look like stained glass, have sought to make it look first like a painting and then like the actual object represented. According to this point of view, the perverted genius who, in the Borghese Palace at Rome I think it was, painted upon tables, papers and books so realistically that almost all visitors attempt to pick them up, would be an artist of the highest order. The truth appears to be that realism in itself is not a highly desirable quality, even in pictorial art. The modern schools of painting are revolting from it, and the best critics are preferring more and more the unrealistic Italian painters of the fourteenth and fifteenth centuries to the realistic artists of later ages. If a painting have beauty of content, line, colour

and composition, the realism is an entirely minor consideration; and how much more is this the case with stained glass, which because of technical limitations should never attempt illusion!

The modern glass-painter who puts in his windows a great glaring figure of realistic character achieves obviousness at the expense of intellectual value. Such figures we take in at a glance or at half a glance. They are eminently unarchitectural, break the structural contours, and call the attention immediately from the large divisions. Like an advertisement, they catch our eye, but like an advertisement also, they give us little in return for our attention. The carefully thought-out detail, the content of subject, the deep strong virile colour, in short the intellectuality of ancient glass, are painfully lacking in the great majority of these modern creations.

In regard to the colouring of mediæval glass, it should be noticed that its effect is never obtained by the use of large fields. Small pieces of blue and red and other colours of primary hue are placed next to each other. From a distance these colours combine to form one tone of entrancing brilliancy. As Dr. Durham has called to my attention, mod-

ern art made the discovery that the finest
colour effects are produced, not by mixing the
paint before it is put on the palette, but by
placing bits of the elementary hues alongside
of each other on the canvas and leaving the
eye to fuse them. For example, if we want to
produce a purple there are two methods of
doing so. We may mix the blue and red
paint together, and then colour our glass or
our canvas, and this is the usual manner of
procedure. The more effective way, however,
and the Gothic way, is to place very small bits
of blue and red beside each other and let the
eye blend them to form purple. By this means
the Gothic glass painters not only achieved a
richer and more vibrant tone, but they avoided
running into obviousness by the use of broad
fields of colour. A window made on this
mosaic system does not strike the eye to the
same extent as would a window in which are
used the same colours and in the same amount,
but in broader fields.

Another indication of the intellectual cali-
bre of the Middle Ages, of their passion for
learning, is to be found in the representations
of the Liberal Arts in iconography. These
seven disciplines — Grammar, Dialectic,
Rhetoric and Arithmetic, Geometry, Music
and Astronomy, were merely the subjects

included in the curricula of the mediæval universities. Few graduates of American colleges would be inclined to set up a statue to Latin, Greek or Trigonometry. And yet this was precisely what the Middle Ages did, and did repeatedly. For there is hardly a cathedral or an important building of the period that does not, or did not, contain somewhere a representation of the disciples.

With the seven Liberal Arts was generally associated the figure of Philosophy. In the mediæval conception, Philosophy included infinitely more than religion. It was the love of learning in the deepest sense of the word, and this learning included naturally the study of that eschatology which was so vital and living in the thirteenth century. To the mediæval mind, Philosophy was at once the end and the consummation of all learning. It was through knowledge of the tangible that man rose to grasp the intangible. His finest mental endeavour, the best training, were necessary to fit him for the contemplation of the divine. Accordingly, Philosophy is always represented as the queen of the other arts. In the Ivrea mosaic she is seated in the centre — the position of honour — and wears a crown. This mediæval conception of religion differs significantly from that of the present day.

Instead of lifting man up to appreciate an intellectual religion, we have debased religion to bring it down to the level of the meanest understanding.

In a mosaic at Ivrea it is also notable that Dialectic occupies the second most important position to the left of Philosophy (for in northern Italy, the usual law of hierarchical precedence is often reversed so that left, instead of right, is the side of honour). Dialectic is not taught in our American universities, and for an excellent reason. There are probably to-day very few students capable of studying such a course, and it is certain that there are no professors who could teach them. Our nearest substitute is Logic, but an inspection of a mediæval text-book on Dialectic will suffice to show how infinitely more subtle, difficult and intellectual was the mediæval subject. It is very significant that in the Ivrea mosaic the highest places should be given to Philosophy and Dialectic. The two great characteristics of the Middle Ages that we find reflected in all mediæval thought and in all mediæval art are the love of Philosphy and the love of Logic. It will be well to note how these passions are expressed in the Gothic cathedral, that consummate product of the mediæval genius, for whose perfection

the philosopher collaborated with the sculptor and the glass-painter, the dialectician with the architect.

The logical structure of the Gothic church has long been recognized. Every stone follows as a dialectic necessity. The foundations, with the buttress spurs, proclaim the rib vault of the soaring nave. Given the buttresses, the design of the entire church is in a measure determined. Contrast with this logic of the Gothic construction the dome of St. Peter's at Rome where (as Professor Moore has shown) we see buttresses formed of coupled columns vigorously applied to the drum where there is no thrust, and where we see ribs appliquéd on the surface of the cupola itself, in such a manner that, far from gathering or relieving the structural strain, they merely increase it by so much added weight.

In the Gothic church, the ground plan announces that the weight of the structure is carried on a skeleton frame, that the wall surface has been removed and replaced by glass, adding little extra weight to the points of support, and requiring but a thin screen of masonry beneath. The section of the piers is determined by the archivolts and ribs. The size of the buttresses even gives the height of the church. For the mediæval masons

did not waste stone. They experimented until they discovered how much was necessary to support the weight of the vaults; and they would have considered it a violation of that strict principle of logic to which they were so bound to employ more than was needed. If the plan of a modern building, say the Boston Public Library, be compared with that of Amiens, it will be seen what the study of logic did for mediæval art. From the plan of the modern edifice, it would be impossible to determine what system of roofing was to be employed, what were the dispositions of the interior, how many stories there were to be, where the windows were to be placed, or even the purpose of the edifice. The mediæval building shows a strictly unified conception growing out of a mind trained by the practice of dialectic. The modern structure shows the aimless rambling of an untutored intellect. Yet planning is considered the forte of modern architects.

The central fact, the postulate of a Gothic church, is the rib vault. As a necessary conclusion follow not only the peculiar type of plan, but the entire edifice with its forests of columns and pinnacles, its varied and rich ornament. From the rib vault were derived by a

logical necessity the pointed arches which lead us, as Suger remarked in the twelfth century, " into a region which, if not heaven, is neither yet entirely of this world." From the rib vault followed the long vertical lines of the system, shooting upwards like sky-rockets, carrying the eye and the emotions towards the serenity of the æther. From the rib vault came the blazing windows of stained glass, filled with harmonies of purple and red and blue. From the rib vault came the tracery of ever-varied design, vining the windows and even the arches. From the rib vault came the buttresses which give strong, powerful lines to the exterior design, and introduce an ever-changing play of light and shadow. From the rib vault came too the mighty flying buttresses with their rugged power and grandeur, their Alpine majesty. From the rib vault, in short, came the entire Gothic cathedral. And there was nothing adventitious about this development. Step by step, the evolution was accomplished, necessarily, logically, dialectically. Given the rib vault, everything else followed because it was logical that it should follow. It was to training in dialectic, in reasonableness, in rationalness, that the Middle Ages owed Gothic architecture.

This spirit of logic did not stop with the main lines of the edifice. It was carried into the most minute details. The gargoyles, of such charming decorative effect that they have been frequently copied in modern buildings in a perfectly meaningless way, were evolved in the Gothic structure for a definite and specific end, that is, to throw the water of the gutters far from the walls, so that it might not corrode the stone. The pinnacles which crowned the buttresses, and which modern architects (at St. Patrick's in New York, for instance) have reproduced for purely decorative reasons, were invented by the Gothic builders as a means of stiffening the outer buttresses by the addition of extra weight. Even the mouldings, far from being purely ornamental, were so profiled as to prevent the water from trickling down the exterior walls. A Gothic capital is a very different thing from a classical capital. The architrave that rests on the latter would be quite as secure if placed directly on the shaft. The Gothic builders, however, gave the capital a structural function, which was that of adjusting a larger load to a more slender support. If we remove the capital, the entire building comes crashing about our heads. This feeling for logic and unity led the Gothic

architects of the best period strictly to sub-
ordinate all detail to the demands of archi-
tecture. The sculptures, far from disturbing,
are an integral and essential part of the archi-
tectural composition. The figures are in-
trinsically beautiful and full of content.
Indeed, in such a work as the western portal
of Chartres, the Gothic artist produced
sculpture, which, considered for itself alone,
is unexcelled, I do not hesitate to say, by any
ever executed by the hand of man. These
statues combine the " singing line " of Botti-
celli, the tenderness of the Sienese, with a
certain sincerity that is purely Gothic. Yet
such beauty and significance are never at-
tained at the expense of the repose of the
entire edifice. In the sculpture as in the glass
the Gothic artist expressed ideas, ideas so big
that they are not infrequently beyond the
grasp of us degenerates of the twentieth cen-
tury, but, notwithstanding, he has never for an
instant sacrificed to his detail the unity of the
building as a whole. A modern artist, having
infinitely less to convey, would still have been
unable to say it without ruining the archi-
tecture. The mediæval artist, on the other
hand, contrived to give to his glass and to his
sculpture just that decorative character which
was required to lend the past perfection to
the Gothic building.

BEYOND ARCHITECTURE

Although Logic was the favourite art of the Middle Ages, it was still only the hand-maiden to the super-art, Philosophy. It was in the service of Philosophy that the cathedral was primarily built and it is of Philosophy that it is primarily an expression.

This philosophical content was conveyed largely by means of symbolism. It is necessary to draw a sharp distinction between allegory and symbolism. By allegory I mean the use of figures which in themselves have no reality, but are merely personifications of abstractions. By symbolism, on the other hand, I mean that infinitely more subtle and intellectual system by which figures that in themselves have a perfectly definite and tangible reality still are made to shadow forth or suggest some other idea. Allegory of the most bald and obvious kind is the plague of modern art. Everywhere, for example, we see dry and uninspired figures of Electricity, Progress, Autumn, Industry, and the like. Symbolism, on the other hand, we find in the plays of Ibsen, where a character in the drama is perfectly real and logical and self-consistent in itself, but also suggests to our minds another reality. Now mediæval philosophy is expressed in the cathedral by means of a peculiarly subtle system of

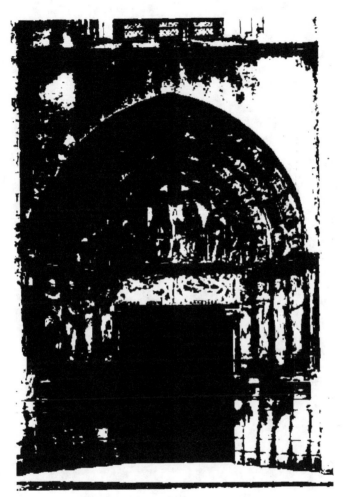

Portal of the Cathedral at Senlis

symbolism. Allegory is rarely used. The example of the Liberal Arts, cited above, is one of the few I recollect, and even that is by a variety of expedients given a subtlety and intellectual character quite at variance with modern allegorical conceptions.

It was the profound conviction of the Middle Ages that the Bible was a book of double meaning, that, in addition to the actualities narrated, each event foreshadowed or reflected another greater event connected with the Life and Passion of Christ.[1] This same system was applied not only to the Bible but to the entire visible and material universe. Thus, to the mediæval mind, reality was but a symbol of unreality, matter but a reflection of the immaterial. Our earth became only a shadow of heaven. Everywhere in the things and objects about us God has implanted the image of eternal truth. It is a thought of singular beauty that grips one more deeply the longer one dwells upon it. But the mediæval philosophers did not stop there. They were tempted to read in this book of double meaning, the world, and to interpret its symbolism and significance. Studying nature with the

[1] This aspect of mediæval art has been made comprehensible to the modern age by Emil Mâle in his immortal work — I almost wrote poem — *L'Art Religieux du XIII° Siècle en France*, a book now happily available also in an English translation.

[43]

aid of the Bible and their own poetic imagi-
nation, the mediæval sages arrived at results
strange, but hauntingly beautiful. By their
musing every least object in the world was
vested with meaning. Profound mysteries
were concealed in every flower, in every tree,
in every cloud that chanced to float across the
sky.

Especially was this mystic interpretation ap-
plied to the most profound of books, the Bible.
If God had implanted symbolism in every
form of the material world, how much more
must he have imparted it to His revelation, to
the book in which was written all that man
need know for his enlightenment and salva-
tion. And so, for the Middle Ages, the Bible
became the mystery of mysteries. In every
word lurked a hidden meaning, in every
phrase a double significance. And this mysti-
cal interpretation was carried over into the
imagery of the cathedral. Thus when we see
represented in the stained glass or in the
sculpture some personage or scene from the
Old Testament, we may be very sure the artist
intended to suggest to our minds also another
idea of which this scene was but the symbol.
When on a capital of the cathedral of Verona,
we see Jonah vomited forth by the whale,
we are to think of Christ who descended into

Limbo, and on the third day arose from the dead. When we see Melchisedech, we must think of another priest and another king who offered bread and wine to His disciples. When we see Adam, we must recall that Christ is the new Adam, who redeemed the world as the first Adam had lost it. When, in the scenes of the Crucifixion, we see Mary and John standing at either side of the cross, we are to think, not only of the Mother of God and the beloved Apostle, but of the Church, which, by means of the Crucifixion of Christ, supplanted the Synagogue. In the exquisite relief of the Deposition by Benedetto, the figures of the Church and the Synagogue are actually introduced, like persons living and present at the scene. The Synagogue, with shattered lance, is pushed down into the dust by an archangel. The Church holds a chalice in her hand. In this relief, there are introduced on either side of the cross also figures of the sun and moon, other symbols of the Church and the Synagogue. In Gothic representations of the Crucifixion, Mary and the Church are commonly identified, and the Virgin holds a chalice in which she catches the blood that flows from the side of Christ.

In the prophet of Carpi, who holds his head in his hand, and whose features express

so eloquently the strength and power of his prophetic vision — a vision of hope and ultimate salvation not untinged by a comprehension of the sadness and tragedy of the world — we are to see not only that Isaiah who had proclaimed *Ecce Virgo concipiet,* but we may recognize the features of the Apostle to the Gentiles. In a window of the cathedral of Chartres, the four Evangelists are represented standing on the shoulders of the four major prophets. The glass-painter clearly wished to indicate that the Evangelists found their points of support in the prophets, but saw farther and more clearly. The mediæval artists never wearied of placing in parallel the four Evangelists, the four rivers of Paradise and the four cardinal Virtues; the twelve Apostles and twelve Prophets. In the archivolt of a lunette in the baptistery of Parma, we see seated the twelve Apostles, each bearing a medallion with the figure of a Prophet.

One of the conceptions which most powerfully weighed upon the spirit of the Middle Ages was the mysterious property of numbers. The Greek philosophers had long meditated upon the subject, and Pythagoras had sought to find in numbers the explanation of the entire universe. The Middle Ages adopted the

idea with passion. The great Isidore of Seville wrote a long treatise on the subject. Of all numbers the most mystic were four and three, their sum, seven, and their multiple twelve. Throughout the mediæval cathedral, as throughout mediæval philosophy, these numbers and their mystic significance echo back and forth like a returning cadence in a piece of music.

In all mediæval imagery, the law of hierarchical precedence plays an important part. The centre is the place of honour, right has precedence over left, the upper over the lower. It is, therefore, never by chance that a particular subject is represented in a particular place in the cathedral. If the story of St. John is depicted in one window, the story of St. Peter in another, we may be certain that there is a definite reason why one is placed here and the other there.

The centre of the principal portal, the post of greatest honour, was generally given to the figure of the Redeemer. To illustrate the wealth of thought bestowed upon every detail in Gothic art, let us study the two little animals which are placed under the feet of the Beau Dieu at Amiens. A careful examination will reveal that these figures, which at first sight might be taken to be purely

decorative, are, in reality, the aspic and basilisk. Now, in the bestiaries — those strange, unnatural histories composed by the united imaginations of antiquity and of the Middle Ages, and which combined a complete ignorance of scientific truth almost as profound as that displayed in some of the books on natural history until recently in use in our public schools, with a poetry such as only the Middle Ages could have read into such a subject — there is a great deal about the aspic and the basilisk. The aspic is a kind of dragon that one can charm with songs, but who is on his guard against the charmers, and when he hears them, places one ear against the ground and closes the other with his tail so that he can hear nothing. Thus he escapes being taken. The Middle Ages found no difficulty in understanding this singular animal. For them, the aspic was the image of the sinner who shuts his ears to the words of life — that is, the Gospel. The basilisk, on the other hand, has such a nature that when he has passed the seventh year of his age, he feels an egg grow in his stomach. Thereupon he is amazed at himself and suffers the greatest pain that a beast can suffer. The toad, another bestiary animal, has such a nature that he smells the egg which the basilisk carries,

and as soon as it is laid he goes to cover it. The young basilisk hatches out with the head, neck and breast of a cock and the tail of a serpent. He then goes to live in a crack in a cistern. He is of such a nature that if a man see him first *he* dies, but if he see the man first the man dies. He has, moreover, such a nature that he throws his venom and kills birds. He who wants to kill the basilisk must cover himself with a vessel of glass; for the beast throws his poison with his eyes, and if it strikes against the glass it rebounds on the beast himself and kills him. The basilisk is a symbol of the Devil and is the very one who tempted Adam and Eve, for which he was banished from Paradise into the cistern of Hell. The vessel of glass is the Virgin, in whose womb Christ enclosed himself. Therefore when we see the Beau Dieu of Amiens standing upon the aspic and the basilisk, it is evident that we have represented in reality the triumph of Christ over Sin and Satan. If you will turn, not to your Revised Version, but to the Vulgate, you will find that the Psalmist says: " Thou shalt trample on the aspic and the basilisk, and the dragon and adder shalt thou cast under foot." Indeed, a close examination of the Amiens pillar will reveal the adder and the dragon, carved not far from

the aspic and the basilisk. The mediæval artist has represented the profound dogma of primary sin and redemption. It is peculiarly fitting that this fundamental conception of the Church should be placed in the most important position of the cathedral. Such is the meaning of the two little animals, one of the smallest of the myriad details with which the Gothic church is covered.

The same sense of propriety, the same sense of order and of unity pervades the iconography of the entire cathedral. M. Mâle has proved that the mediæval church in its imagery is as essentially and as vitally unified as in its structure. The four great mirrors of Nature, of Science, of Morals and of History into which Vincent de Beauvais divides his work upon human knowledge and which in the mediæval conception reflected the manifestation of the glory of God on earth — each finds in the cathedral imagery its appropriate, logical and fitting place. At Chartres, for example, on the north side (the region of darkness and cold), were displayed subjects drawn from the Old Testament, from those ages which awaited the coming of the Sun of Christ. On the south (the region of sunshine and warmth), were told the solemn stories of the life of Christ and the Christian saints.

Over the western portal was enrolled the dreadful drama of the Last Judgment, so placed that the setting sun might illumine this terrible scene of the final evening of the world.

I am sensible how inadequate are my few pages to convey an impression of the beauty and poetry of mediæval iconography. Happily M. Mâle's admirable study is within the reach of all. What I have said may be sufficient to indicate in some measure the type of symbolism used by the Gothic artists. It is through the imagery that in Gothic architecture Philosophy is made to sit crowned, a queen over all the arts, harmonizing and combining them into a mighty unity. It is through the imagery that Gothic architecture acquires its supreme intellectuality, that it becomes not only decorative, but illustrative.

As I use these two words " decorative " and " illustrative " in a special sense, it will be well to define the meaning I seek to convey by them. Mr. Berenson has already acclimated them to painting. By " decoration " I mean to indicate all the *intrinsic* merits of a work of art, all the intellectual qualities that make it in itself pleasing to us. These would include in painting and sculpture, form, colour, line, movement; in architecture, proportion, scale, massing; in literature, style, the choice of

words, verse; in music, harmony, rhythm, modulations. "Illustration" on the other hand indicates all the *extrinsic* merits of a work of art, those intellectual qualities that make it pleasing to us by outside suggestion. Character drawing is an example of illustration applicable to the three arts of painting, sculpture and literature. By means of the sculpture and glass, Gothic architecture became highly illustrative; it conveys to us ideas and pleasurable emotions quite outside of the material building itself.

I think there can be no doubt that an art depends more than is commonly recognized upon its illustrative quality. Over-emphasis of decoration has been a disastrous mistake of the modern age. What one says matters far more than how one says it. The ability for expression, technique — in the last analysis decoration is hardly more — is indeed a necessary prerequisite; but if art stops here it has essentially failed. *Decoration is merely a means to the supreme end — illustration.* This is the whole gospel of art.

Modern criticism is beginning to perceive at last the value of illustration. Mr. Berenson after having seen importance only in decoration, has now reversed his opinion. Knowledge of oriental art has opened our eyes to

the fact that the artist who sets himself illustration as his ultimate aim is alone capable of reaching the greatest heights. The decadence of modern art appears to be largely due to the abandonment of all ideals of illustration. Nothing contributes so largely to the feeling of depression caused by an academy exhibition as the fact that most of these painters, for all their technique, have nothing — no joy — to express. It is only illustration that can lift art to the highest level.

That this statement be not misunderstood, I hasten to add that I attach to the word "illustration" an even broader meaning than that given it by Mr. Berenson. I should make it include not only the conveying of a concrete idea but also the expression of an emotion. It was this that Cézanne meant when he spoke of the *petite sensation* he tried to fix upon his canvas. Thus an andante of Beethoven or Brahms would be as completely illustrative as a piece of program music by Strauss or Debussy. An Asia Minor rug may have a strong illustrative element — the good ones in fact do even when the forms are least realistic. Mr. Berenson would doubtless judge Giotto a very poor illustrator because he is not successful in interpreting the finer and more subtle aspects of the legends he paints;

[53]

I should call him a great illustrator because he conveys to me a very definite *mood* — not the same mood evoked by the Legends of St. Francis or of Christ or of the Virgin which he paints, but an emotion of poetry, of joy.

Thus all architecture that is of significance is in a manner illustrative. Surely none conveys an emotion more powerfully than Gothic. But mediæval art is illustrative also in the Berensonian sense. It unites the qualities of a Sassetta with those of a Giotto.

It is a curious though by no means incomprehensible fact, that a race of men is capable of producing more finely artistic thought than an individual. Folk art has almost invariably possessed greater vitality than the productions of any genius. This is, perhaps, another direction in which the highly individualistic modern age has gone astray. It can hardly be doubted that the use of traditional material was a great source of strength to Homer and the tragic poets of Greece. Shakespeare drew his plots from what really was the equivalent of folk tradition. The Renaissance painters found in subjects of a traditional character (although the conventions were already in precipitate decline) an inspiration which is lacking to our modern painters, free to paint what they will. Now of all legends

none was so refined by passing through count-less hands, none so full of life, none so imbued with intellectuality of the highest type as the religious legend of the Middle Ages. The world for twelve centuries had brought its best to the elaboration and perfection of the scholastic system. The straightforwardness and human sympathy of the people, the im-agination of the poets, the deepest thought of the philosophers were there blended and com-bined. By comparison the myths of the Hebrews seem crude, even those of Greece appear lacking in subtlety. It is the posses-sion of this supreme legend that raises the *Divina Commedia* above all other epics. It is the possession of this supreme legend that places on the brow of Gothic art its highest intellectual crown.

GOTHIC ART, THE WAR AND AFTER

THE cathedral of Reims is in ruins. We all know it. We have grown accustomed — almost callous — to the fact. The cathedral of Reims, unequalled for its façade and for its wealth of sculpture, is destroyed. We shall never more study the wonderful glass of the clearstory with its blazing scarlets and reds, the warmest, the most pulsating, the most daring glass-work in all France. The grave saints that lined the portals with faces so full of dignity and Christian fortitude are broken into bits. Even the wonderful angel of never-to-be-forgotten gentleness, so solicitous, so tender, was not spared. What two fires and the wars of six hundred years had left uninjured our age has reduced to ruin. German cannonading was able to destroy a monument the equal of which fifteen centuries of boasted German culture have been unable to produce.

Nor has the destruction been limited to the cathedral of Reims. The region through which the German armies have swept, levelling all to the ground before them, was the

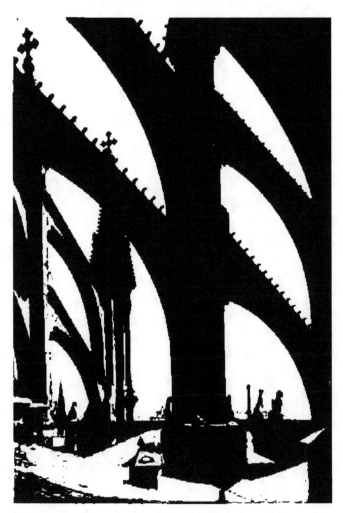

Flying Buttresses of the Cathedral at Reims

classic region, the Tuscany, the Attica of
France.

Gothic art, the most perfect of all expres-
sions of beauty, reached its complete culmina-
tion only in a small district. It was in the
Île-de-France and especially in the region to
the east of Paris that it was born and that it
attained its flower. It was copied from one
end of Europe to the other, but in its pure
essence, at its absolute best, it is to be found
only here. Complete statistics are yet lacking,
but it is certain that in addition to the ca-
thedral of Reims, the cathedral of Soissons,
with its fairy-like south transept, its noble
nave; Saint-Léger and Saint-Médard of Sois-
sons; glorious Saint-Remi; Acy-en-Multien,
with the earliest rib vault in the Île-de-
France; Rhuis, where ribs were first given a
profile; Vailly, with the finest parish façade
of the Soissonnais; Fontenoy, Roye-sur-Matz,
Les Hurtus, Marquivilliers, many other abbeys
and parishes lie in more or less complete ruin.
Since the barbarian invasions art has suffered
no such loss. It is the study of these early
buildings that has opened our eyes to the true
character and true beauty of mediæval work.
Each of the country churches of the Soisson-
nais was a master-work in its way, each un-
rivalled.

It may be that in the centuries to come the other wrongs of this war will be forgotten. We no longer ask whether the Huns did or did not have a justifiable pretext for over-running Italy. To-day we care very little whether Alaric took or did not take Rome, or how long he held it. We have forgotten about the sufferings of the vanquished, the wrongs of the women, the death agony of individuals and peoples. We hardly know even the name of the barbarians who overran Greece. Their conquests, their gains and losses, are recorded only in the obscure pages of dusty histories. What we are acutely conscious of is the fact that Greek art was in great part destroyed, that not a single Greek painting has come down to us, that the works of Menander and Sappho are lost, that the Greek temples are in ruins, that masterpieces of Greek sculpture ended in the lime-kiln. And so it shall be with this war. Other things, however atrocious, time, which heals almost everything, may cure. But the wanton destruction of Gothic art must always remain to the end of time an act which the civilized world can never forgive, a wrong which the Germans have committed not only against France, but against all humanity, against themselves. For centuries still to come Ger-

man children must learn that their forefathers in wantonness and cold blood destroyed the most beautiful of arts, and they must realize that their own lives have by this act been deprived of a source of happiness which they might otherwise enjoy. The barbarians who sacked Rome might plead one excuse — they knew not what they did. They had no conception of art nor of its value. The Germans can plead no such excuse. The Germans knew what they did. They knew the value of what they destroyed.

When the war ends, the question must inevitably arise, what is to be done with the partially ruined monuments left by the Germans. There is grave reason to fear that the mistake of a century ago may be repeated. French Gothic architecture, it will be remembered, suffered terrible damage in the Revolution, but worse than this were the ill-advised restorations which followed. The question of restoration is an exceedingly delicate one. It is the friends, and the very sincere friends of the monuments, who promote it, frequently at great sacrifices. Their zeal and good intentions are undoubted. It therefore seems ungrateful to point to them as dangers. Since, however, an agitation is already being started to restore the ruined

Gothic monuments, it is very necessary to come to a realization of what may only too probably result from misguided enthusiasm.

Gothic monuments are valuable from two distinct points of view. In the first place they are historical documents giving us information about past ages, the philosophy, the building methods, the character of the Middle Ages. This may be called their archæological value. Even more important is their purely artistic value, the joy they are capable of communicating as a thing of beauty. Both these values are liable to, nay almost certain of, destruction by restoration.

From the point of view of the archæologist a restoration puts in his hand a falsified document. It is impossible to be certain what is old, what is restored upon reliable authority and what is merely conjecture liable to be entirely misleading. The very fact that restorations are generally cleverly done makes it impossible to disentangle the old from the new. Only one who has worked for years upon mediæval monuments can realize the extent of the mischief wrought by modern renovations. Paradoxical as the statement may seem, the better these restorations are, the more deplorable is the archæological result.

A few instances of the way in which the modern restorer has led astray the learned may give some idea of this evil. In the ninth decade of the nineteenth century the church of S. Vincenzo in Prato at Milan was restored. It was rescued from almost certain destruction in being used as a chemical factory and reopened to the Christian cult. At that time it was believed that arched corbel-tables were characteristic of all Lombard monuments, and the cornice of the façade was rebuilt with arched corbel-tables. As a matter of fact this motive was not used in Lombardy until the eleventh century, while S. Vincenzo dates from the ninth century. It was forgotten that the corbel-tables had been added by restorers, and archæologists concluded that those of S. Vincenzo were of the ninth century. The entire history of Lombard architecture was consequently confused. Because of the corbel-tables of S. Vincenzo a whole group of monuments of later date was ascribed to the Carlovingian epoch.

Nothing would be easier than to multiply similar instances. The statues of the S. Zeno pontile at Verona are modern, added in the nineteenth century restoration. Yet they have been discussed as ancient by almost all critics of

Italian mediæval sculpture, and whole theories of attribution have been based upon them. The best and most conscientious archæologists have been frequently deceived by restorations. Cattaneo published a modern capital of S. Vincenzo as an example of the Lombard style of the ninth century. Professor Moore was deceived by the modern statues of the façade of Paris. An archæologist of the present day, when he studies a mediæval monument, is obliged to spend weeks in tracing the changes wrought in the nineteenth century. Only so can he be certain what is genuine and what is restoration. And in many monuments even of the greatest importance it is already impossible to prove what is new and what is old. Such buildings are without archæological value, although they may be nine-tenths authentic. It is impossible to be certain that the particular point in question may not be included in the one-tenth conjecture.

The usual plea for restoration is founded upon the æsthetic appeal of a work of art. It is generally felt that the total effect is marred by damaged portions and that the building can be better enjoyed if these are put in harmony with the rest so as not to distract the attention. Yet in point of fact I think even the most tactful modern restoration is

quite as pernicious from an artistic as from an archæological point of view. Modern workmen cannot reproduce nor copy Gothic work. The hardness of modern machine-made methods completely ruins that verve and feeling which is the vital force in mediæval art. Here again the restoration is so much the more mischievous that it is not easy to disentangle the new portions from the ancient. Better a thousand times, from an artistic standpoint, a ruin than a restored building. The ruin may have a certain picturesqueness of its own; at any rate it tells no lies. What is there is genuine, is mediæval. The practised eye may imagine missing portions, reconstructing mentally the building as it was. In the restored building, however, the original beauty is hopelessly and forever lost. Not even the most experienced eye can reconstitute the edifice as it was, strip it of the modern metallic hardness, re-invest it with its ancient poetry. It cannot be emphasized too solemnly that restoration of mediæval work is destruction of mediæval art.

It would be as vain to attempt to restore the ruined Gothic churches as to repaint the lost pictures of Apelles. A Shelley, it is true, might give us, not a lost tragedy of Æschylus (that would, indeed, be impossible), but

another poem conceivably as beautiful; but there are no Shelleys among modern architects. The touch of the modern on mediæval monuments is a profanation and a destruction. During the last half century the mediæval monuments of all Europe have been gradually, little by little, replaced by modern copies under the name of restoration. The inferiority of the copies is so great, that I have often felt that it would be better to tear a building down absolutely than to make an unbeautiful misleading copy for the misinformation of posterity. No one—least of all an art critic—suggested, when the Mona Lisa was stolen from the Louvre, that the loss could be made good by having a copy painted and replaced in the frame. Yet how much more nearly would a copy of the Mona Lisa approach the value of the original than a copy of the cathedral of Reims could approach the building which has been destroyed!

We must realize frankly, therefore, that the destroyed churches of France are in danger of a fate even worse than that which has already befallen them. Ill-advised enthusiasm among people whose perceptions are not specially trained is very liable to result in crowding the competent authority — which is the official *Commission des Monuments His-*

toriques — into sanctioning or even promoting the restoration of these buildings.

Gothic churches cannot and must not be restored. What is done cannot be undone. The losses caused by the Revolution in ignorance were great. Of an important part of the heritage which earlier centuries had already in ignorance depleted, the Germans have in knowledge deprived all humanity. Let us not make the matter worse and still further reduce the patrimony by restoration. Works of restoration should be undertaken only when necessary to prevent further disintegration. Let the destroyed monuments of France stand as ruins, but poetic, beautiful ruins, not machine-made modern churches. Let them stand a sempiternal reproach and source of shame to the Germans; but let it never be said that what their enemies had spared their friends destroyed.

THE GOTHIC WAY

THE modern schoolboy reads in his history of the three monastic vows of poverty, chastity and obedience. He shrugs his shoulders in contemptuous amusement and passes on.

The modern architect sees the Gothic cathedral. He wonders a moment, shrugs his shoulders in bewilderment, and he passes on.

That the modern world has often failed to appreciate the art of the thirteenth century is, I think, very largely due, paradoxical as the statement may seem, to the very greatness of Gothic. The mediæval cathedral is composed with an intellectual power that baffles the twentieth century observer. It is, indeed, the same poetic content that makes the monastic vows incomprehensible to the schoolboy and the Gothic church incomprehensible to the architect. The mediæval mind was essentially different from ours.

It is difficult for us of the twentieth century whose ideals are wealth, self-indulgence and individualism, to understand how for centuries poverty, chastity and obedience were

Sassetta, Mystic Marriage of St. Francis, Chantilly

the enthusiasms for which men sacrificed and laboured. A gulf which is not to be bridged separates the Gothic point of view from the pragmatic modern age. The mediæval conception seems to us out-lived, as austere and morose as Puritanism. The thought of renunciation chills us.

Yet in the Middle Ages the ideal of renunciation was never associated with gloom. In the painting of Sassetta representing the mystic marriage of St. Francis with his beloved Lady Poverty, there is, as Mr. Berenson has pointed out, no note of austerity. And in this the picture, although painted in the Renaissance, is thoroughly mediæval. The wedding with Poverty, which we of the twentieth century so keenly dread, is here represented without horror or repulsion. On the contrary, the face of the bridegroom breathes serenity and joy; Lady Poverty herself is calm and beautiful; an ineffable tranquillity surrounds her as, accompanied by her ever faithful sisters, Chastity and Obedience, she floats away so softly, so lightly amid the radiant beauty of the Sienese landscape.

Thus for the Middle Ages poverty was not as for us a curse, but a blessing. Into the writings of the poets and sages who meditated upon the mystic mistress of St. Francis, there

enters no note of despair. Dante alone touches the subject with a gentle sadness. St. Francis, he says, married such a woman, that she mounted with Christ upon the cross, while Mary stayed below:

Che per tal donna giovinetto in guerra
 Del padre corse, a cui, com' alla morte
 La porta del piacer nessun disserra;
E dinanzi alla sua spirital corte
 Et coram patre le si fece unito.
 Poscia di dì in dì l'amò più forte.
Questa, privata del primo marito
 Mille e cent' anni e più dispetta e scura
 Fino a costui si stette senza invito;
Nè valse udir che la trovò sicura
 Con Amiclate al suon della sua voce,
 Colui ch'a tutto il mondo fe' paura;
Nè valse esser costante nè feroce,
 Si che dove Maria rimase giuso,
 Ella con Cristo salse in su la croce.

But elsewhere poverty is greeted with joy, with ecstatic rapture. The spirit is the same as that in which Plato, the most poetic of Greek philosophers, greeted the sister virtue of Chastity, when he makes Socrates say that a man who has escaped from love is freed from the most tyrannous, the most cruel of masters. Thus the Middle Ages felt that the man who broke the bondage of wealth had acquired a new freedom, a new power to rise to heights of idealism and spirituality. Poverty meant renunciation of the non-essen-

tial, of the vanities, for an idea and an ideal.
Alain de Lille says of poverty that she knows
no fear and therefore is the leader in the battle
of life. Only the man who is unburdened by
selfish cares can devote himself heart and soul
to some greater interest outside of himself.
And as by poverty man rose to the heights of
achievement, so, in the conception of the
Middle Ages, it was wealth which chiefly
impeded his progress. The scholastic philos-
ophers are unanimous in denouncing avarice
as the most hideous of sins.

Even antiquity had realized that artistic
achievement was fostered by poverty. Pov-
erty, says Petronius, is the sister of intellectual
attainment, *bonae mentis soror est paupertas.*
He blames the decadence of Roman art upon
the spread of wealth and the consequent lux-
ury and debauchery. He recalls that Lysippus
died of want through seeking to give the
utmost perfection to one statue; and that
Myron was so poor that at his death no heir
appeared to claim what he had left.

It is easy to read the ideal of poverty in
the Gothic church. The mediæval artist
was poor. The present-day architect de-
spises him as hardly better than a labourer.
He lacked entirely the education which
wealth gives to his modern brother. There

were no architectural schools, endowed with
untold millions, such as we have, where there
is lacking for an architectural education
nothing save the sense of the beautiful.
No railroads made it possible for the me-
diæval master-builder to journey from one
part of the country to the other, so he was
unable to direct the construction of more
than a single building at a time. Thus he
earned little, but was able to put into the
one piece of work which he did do, the energy
the modern architect divides between many.
The poverty of the mediæval master-builder
obliged him to superintend the actual con-
struction in person, instead of leaving a corps
of workers to interpret his drawings. This
was his greatest gain. For a true work of art
must be executed by the man who designs it.
On paper or in the imagination, those essen-
tial lines upon which the artistic effect prima-
rily depends can never be studied to as great
advantage as when the artist actually sees the
object created taking form beneath his hands.
The very tediousness of the execution gives
opportunity for more mature thought, for
more careful study. This is the reason that
machine work is so invariably bad. It is made
from drawings, and the man who executes
works thoughtlessly. Nor is the artist able

to study the object as it grows. Ever since the time of the Renaissance, architecture has been erected on the machine principle. It has become an industry, a business, and has ceased to be an art. The Gothic cathedral, on the other hand, was constructed by hand. It received without stint all the energy, all the genius of the master-builder. Obviously wealth could never be accumulated by such Quixotic generosity.

Gothic architecture was born in poverty. The story of its birth is as exciting as that immortal passage at the beginning of the " Agamemnon," in which Æschylus describes the beacon fires by means of which the news of the fall of Troy was signalled from mountain top to mountain top around the Ægean Sea · to much-golden Mycenæ. The spark was kindled in poverty, at a modest hamlet on the marshy banks of the river Sesia in the Lombard plain.

A small monastery was founded, and the good monks in the year 1040 set about building their church. Funds were scarce, and, in that flat plain, there were no trees to be found within many miles. On the other hand, good building brick was abundant. Therefore, the builders of Sannazzaro Sesia determined to find a method of erecting a church of brick

and roofing it over without using timber. A simple device was hit upon. Instead of the scaffoldings of wood, which, for centuries and centuries had been employed in building vaults, they erected a scaffolding of brick. The rib vault had been discovered. From that moment Gothic architecture became inevitable.

Mark how the fire runs. Immediately afterwards we find it smouldering in a chapter-house of the cathedral of Novara, a few miles away; then, gaining headway, little tongues of flame appear here and there throughout Lombardy. Then, flashing up, the beacon fire bursts forth in all its glory from the great vaults of S. Ambrogio of Milan. It is echoed in far-off Dalmatia, at Zara. Answering fires are kindled in southern Italy; Montefiascone, S. Robano, and Corneto Tarquinia blaze from their mountain tops. Even the lowlands are kindled at Aversa. To the westward, fire after fire is lighted, carrying the news to France. Fréjus passes the word to Marseilles; Marseilles transmits it to Moissac, Moissac to Saintes. We are now on the shores of the great western ocean. From Saintes the signal is flashed to Quimperlé in Brittany. From Quimperlé it at last reaches the Île-de-France at Acy-en-Multien.

At Rhuis, now destroyed, the French archi-
tects first began to apply their genius to
the great principle discovered in Lombardy.
The possibilities of the new construction
became known and appreciated. The archi-
tects advanced step by step, slowly, logically,
sanely, thoughtfully, economically, always in
poverty. A new architecture came into being.
Pointed arches, soaring spires, mighty flying
buttresses were flung towards the skies, first
in France, then throughout the length and
breadth of Europe. Not only Umbria but
a whole continent was stretching arms of stone
to heaven in prayer.

At each step of this evolution, the most
dramatic and tremendous in the history of art,
the same goddess, Poverty, presided over each
development. There is no waste in a Gothic
church. Stained glass, the most sumptu-
ous, the most decorative of accessories, was
adapted, why? Because by means of its use,
the cost of the building could be reduced.
It is less expensive, as well as infinitely more
beautiful, to construct a wall of glass which is
light, than to build one of solid masonry
which is heavy and requires an enormous mass
of masonry below it. There is never a buttress
nor a pinnacle, nor a gargoyle, nor a bit of
tracery, introduced into the Gothic church,

which does not have its strict justification from an economic and structural standpoint. The most decorative of all arts makes the least effort to be decorative.

This art depended for its effect not upon costly materials, not upon multitudes of workmen, not upon vast material resources. The Gothic builders did not possess the rare marbles which make gorgeous the monuments of Byzantium and vulgar those of New York. Restricted resources caused the work to proceed with extreme slowness. More is built upon an American skyscraper in a year than was built upon a Gothic cathedral in a century. The Middle Ages lacked completely that wealth upon which our modern architecture is dependent. By means of its poverty, mediæval art attained a fine calibre of which ours, because of its wealth, is utterly incapable. In buildings of small dimensions and by workmen untravelled and unlettered was evolved the most intellectual architecture the world has seen.

Distasteful as is the ideal of poverty to us moderns, that of chastity is even more repellant to our way of looking at things. We feel that the celibacy upon which the Middle Ages insisted so strongly is ascetic, contrary to natural laws. Especially do we feel that

[74]

this is so in art. The study of the nude is
the most emphasized task set the young
student. Ever since the days of Masaccio
and Signorelli and Michel Angelo, the
rendering of the nude has been believed to
be the highest function of the mature artist.
Certainly to this conception of art we owe
masterpieces which the world is infinitely
richer for possessing. From the " Theseus "
of Phidias, the " Hermes " of Praxitiles, the
" Baptism " of Masolino, the " Danaë " of
Correggio to the " Age of Bronze " by Rodin,
what a series of forms of inexpressible beauty
has this conception called forth!

Indeed, in the last analysis, sex is the illus-
trative idea which vitalizes that art which
more than any other has won the universal
homage of mankind. The early nineteenth
century profoundly misunderstood the nature
of the Greek spirit. Keats, David, Canova
conceived it as self-restrained, metallic and
icy, colourless as the moonlight on the snow.
Something of this old misinterpretation still
lives on among us. The Parthenon, Greek
statues, subconsciously float in our memories
as images of marble, white, ghostly as plaster
casts. It requires a real effort to grasp the
meaning of the archæological evidence, to
realize that Greek art was not anæmic, but

red-blooded, not pale, but full of strong
colours, not neurotic, but pulsating with
life. Indeed, in this very vitality lies the
secret of its illustrative power. It is full of
sex. The emotion it conveys is the emotion
of sex, the beauty it interprets is the beauty
of sex! This fact has very largely been mis-
understood or ignored because the type of
sex which appealed with especial power to
the Greeks is considered perverse and re-
pulsive by the modern age. Not being will-
ing to grant that an art obviously of the
highest type could have been inspired by
ideals which seem to us depraved, we have
willed not to understand. Yet delight in the
nude, and especially in the nude male, is
the key-note of Greek art. Where else has
the vigour of youth, the play of muscles, the
glory of manhood found a like expression?
It is the ideal of masculine sex which the
Greeks eternally glorified; this is the beauty
they never wearied of interpreting. It is
this which is illustrated by Greek sculpture.
Greek architecture, like Gothic, was highly
illustrative in character. It was merely a
frame for the sculptures — the apotheosis of
a frame, but still a frame. In a manner the
Greek temple was the converse of the Gothic
cathedral. Unity was achieved in the latter

by subordinating the sculptures to the architecture: in the former by subordinating the architecture to the sculpture. Without the sculpture the Greek temple is as unmeaning as the music' of a song without the words. And the sculptures were the idealization of male sex, that and that only. Thus the entire Greek temple was made a glorious hymn in praise of sex.

At the opposite pole is the mediæval ideal of chastity. The philosophy of the Middle Ages was, of course, primarily Christian, and in this fact lies one of the reasons that it is so seldom understood by moderns. There can be no doubt that chastity was a very fundamental part of the teaching of Christ, and that until the sixteenth century the idea was accepted by the Christian church. Now the problem that was proposed to the mediæval builders — and it was the same problem that was proposed to the Renaissance painters — was to produce an art which should embody the ideals of the Christian religion. Let us see how the solutions offered by the Gothic and by the Renaissance artists compare in regard to this doctrine of chastity.

From the earliest times at Rome, the Christian artists had perceived that too great naturalism in the rendering of the human

figure was fraught with danger to this cardi-
nal point of Christian ethics. The old Roman
art, full of what we have been taught to call
tactile values, and their necessary accom-
paniment, sensuality, was adopted in the
earliest churches, but was immediately after-
wards discarded. In an incredibly short
time art underwent a complete transforma-
tion. The nude youths and maidens of
classical times were supplanted by long rows
of prophets and veiled matrons, full of hier-
atic dignity. Naturalistic positions and at-
titudes were avoided. For tactile values were
substituted new but not less beautiful prin-
ciples of art, line and colour. The old beauty
was discarded and a new beauty, no less com-
pelling but completely adapted to the ex-
pression of the Christian dogma, was dis-
covered. Modern critics, following the
worn-out pathway of Vasari, have repeated,
one after the other, that this change in the
character of art was merely a decline, due
to the barbarian invasions. It was nothing
of the kind. A decline did subsequently take
place, but the earliest works of the Christians,
compared with the works of the pagans they
supplanted, mark, not a step backward, but
a notable step in advance. The Christian
artists accomplished the astounding achieve-

ment of creating out of their imaginations a new art adapted to the new conditions, and an art which was singularly beautiful and thoughtful.

This was the tradition which the Gothic artists inherited. It was their problem to create figures which should be beautiful enough to suggest the delights of Paradise and yet from which any taint of the sensual, any smack of the houris of Mahomet, should be absent. It was necessary for them to avoid the earthly, the materialistic, the mundane.

When forced by the nature of their subject to depict the nude, as in the cycles of Adam and Eve and the Last Judgment, the mediæval sculptors invariably contrived to deprive their figures of all sensual suggestion. Elsewhere they generally confined themselves strictly to draped forms, and in order that the taint of sex might be still further eliminated, they represented the figures in an unnaturalistic manner, usually with distorted proportions. In the western portal of Chartres, the artists by elongating the proportions have given their figures precisely that otherworldliness which was required. Nothing could be less sensual than this grave row of prophets and prophetesses. Yet he would be a bold critic who would dare pronounce that

[79]

any naturalistic figure ever produced in the golden age of the Renaissance was absolutely less lovely, possessed more grace or sweep of line, more charm, greater dignity, higher decorative significance. I smile when I read it soberly stated that the Gothic artists did not understand the proportions and anatomy of the human figure. In the capitals of this same portal of Chartres, just above the excessively elongated figures of the jambs and worked by the hand of the same master, are placed, where the exigency of the treatment demanded it, figures as perfectly proportioned as any produced by a Renaissance master. The sculptures of Chartres are probably derived, at least indirectly, from the sculptures of Languedoc. This province in the early twelfth century possessed the most vital and pregnant plastic art of Europe. In the unforgettable " Annunciation " of the porch at Moissac, we find the proof that the elongation of the figure in twelfth century art originated in the desire for chastity. Here the sculptures are placed, not on the jambs as at Chartres, but in panels. Nevertheless, the elongation is equally extreme. The sculptor of Moissac has undoubtedly created a plastic work of surpassing loveliness, and he has turned the restraint imposed by his ideal into a source

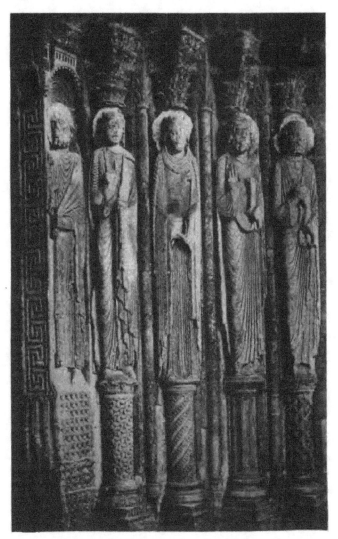

Portal of the Cathedral at Le Mans

of additional beauty. Without the distorted proportions, he could never have attained the grace, the sentiment, the refinement with which he has actually succeeded in embuing his work. At Chartres the same elongation, doubtless introduced for the same idealistic reason, has resulted in the same decorative beauty, and, in addition, has lent to the sculptures an architectural character, a harmony with the vertical lines of the jambs which could not have otherwise been attained.

In the drawing of stained-glass windows the ideal of chastity led the Gothic artists to a similar elongation of the figure, and resulted in a similar enhancement of the grace and beauty of line. As the Renaissance approached and the ideal of chastity weakened, the proportions become naturalistic. Simultaneously, mastery of line was lost, so that the figures became not only less intellectual but also less decorative.

The ideal of chastity reigns throughout Gothic art. The realistic representation of the human form, and especially of the nude, was carefully and purposely avoided, in stained glass, frescos, miniatures and ivory-carvings as in sculpture. This lack, with which the Gothic artists have been especially

reproached, is in reality one of their greatest claims to glory. They produced a beauty no less vital, no less great, than that conferred by tactile values, and they still preserved their art entirely untainted by sensuality; they still offered a complete and perfect solution to the problem proposed them by the Christian Church.

Let us now compare a little and see how the Renaissance artists solved this same problem. It will be remembered that in his " Northern Painters," Mr. Berenson remarks that the eclectic artists frequently coquetted in unseemly manner with the flesh and the devil while crucifying Christ or torturing a martyr. As a matter of fact, the practice far antedates the times of the eclectics and begins with even the earliest masters of the Renaissance. The study of the nude was one of the great aims which the Renaissance artists set themselves. The distinctly sensual suggestion in such pictures as Pier della Francesca's " Burial of Adam," Masaccio's " Baptism " of the Brancacci chapel, the paintings of Signorelli at Orvieto, and others of like kind is indisputable. Now I should not wish to be understood as disapproving of the use of the nude in art. Sex may be a beautiful thing, an inspiring thing, and it may very well be the

mission of the artist to point out to us its
nobler aspects. Just as the modern novelist
finds in the love story his favourite and
almost only theme, so the plastic artist, in
treating of secular subjects, may well find his
chief interest in the study of the human body
in its most beautiful phases. Only, let us be
frank about it, as the Greeks were. Let us
enjoy the nude human form as such. Let us
not mix it up with Christianity with which it
has nothing to do, and, above all, when our
sensual instincts are appealed to by a picture
of the Renaissance, let us not imagine that
we are receiving Christian emotions. The
art of the Renaissance, like that of ancient
Greece, is very largely the glorification of
sex. Sensuality is inseparable from the ele-
ment of tactile values which is the keynote
of the Renaissance art of Florence and more
or less of all Italy with the notable exception
of Siena. At Siena alone, we have really
religious art, and at Siena alone the mediæval
tradition is preserved. The other schools of
Renaissance art, one and all, whatever secular
and incidental beauty they attained, never-
theless all failed to answer the primary
problem which had been proposed to them;
they failed to give a satisfactory illustration
of the Christian spirit, because they depended

[83]

for effect upon elements diametrically op-
posed to their theme.

Let us take a few examples. There can
be little doubt that the popularity of St.
Sebastian in the fifteenth and sixteenth cen-
turies was due very largely to the fact that he
was represented nude. Vasari's life of Fra
Bartolomeo contains an anecdote which shows
how profoundly this was true. Fra Barto-
lomeo was, of course, the most religious of all
Renaissance painters, with the possible ex-
ception of Fra Angelico, a pious monk of
S. Marco and a devoted adherent of Savona-
rola. Moved by the exhortations of the latter
he brought to the famous bonfire of vanities
all the drawings of nudes which he had made
in his youth. This did not prevent him,
however, from painting for the church of
S. Marco a picture of St. Sebastian, accord-
ing to Vasari, wholly undraped. This was
set up in the church, where it caused, says
Vasari, so many evil and light thoughts
among the congregation that the monks were
obliged to remove it to the chapter-house.
Even more shocking, to me, are the famous
frescos of Michel Angelo in the Sistine chapel.
Let us stop for a moment to think where we
are. This is the private chapel of the pope,
Christ's Vicar upon earth, the visible head of

[84]

that Christian religion, one of the fundamental
tenets of which was the doctrine of chastity.
In this place, which should be the fountain-
head of Christian inspiration, Michel Angelo
painted upon the ceiling and west wall frescos
with which everyone is familiar. In these
paintings, I see, and we all see, many things,
but among them there is no Christianity. Re-
ligion, perhaps, there may be, the religion
that inspires the Theseus of Phidias or the
ninth symphony of Beethoven, but of Chris-
tianity there is not a trace. We are in the
presence of the glorification of the physical,
of the body in its utmost grace and perfection.
The mysterious sibyls, the grand prophets, the
nude demigods and heroes recall the grandeur
of Prometheus, the struggle of Titans, even
the classic grace of the Elysian Fields, but
never for a moment the Christian Paradise.

The works of Michel Angelo are no answer
to the problem proposed to the master. They
are in no sense an illustration by means of
art of the Christian spirit. Hadrian VI, in
a fit of conscientiousness, rare indeed among
priests in that profligate age, caused the
" Last Judgment " to be expurgated of its most
flagrant departures from the path of chastity.
And greatly as this mutilation is to be re-
gretted, the very fact that it was perpetrated

is an eloquent testimony to the lack of religious feeling in the paintings.

There is nothing more profoundly touching nor more sincere than the adoration of the Virgin in the Middle Ages. Mediæval literature is full of the glorifications of the Mother of Christ, written at once with an enthusiasm and a purity that give them high rank as works of art. This same feeling is also expressed in architecture. Hardly one of the great cathedrals of France but was dedicated to Notre-Dame. Moreover, throughout these cathedrals the imagery is constantly singing the praises of Mary. Not that we find so many of her images; for the Middle Ages were far too subtle and too intellectual to honour the Virgin with endlessly repeated renderings of the same subject — the Mother and Child, such as we find in Renaissance art. They celebrated her glory in a much more intellectual way, by great stained-glass windows, or sculptures, in which were told with a thousand variations the story of her life, her lineage, her joys and her sorrows. The miracles believed to have been performed in her name — and they were legion in number — were constantly commemorated. But her glory was sung in another even more subtle way and one that is peculiarly

mediæval. When, for example, in a window
of Laon, we see the fleece of Gideon, the artist
wishes us to understand that he is really think-
ing of the Virgin, who, according to the
church-fathers, was the fleece upon which
fell the dew from on high. When the me-
diæval artists represent Moses and the burn-
ing bush, they have in mind the Virgin, of
which that bush was a symbol. For, just as
the bush burned without being consumed,
and as God appeared in it, so, according to
the mystics, Mary carried in herself the flame
of the Holy Spirit without being burned by
sensuality. When we see Eve, we are to think
not only of the sinful woman by whose fault
humanity was lost, but of the second Eve, by
whose travail and suffering humanity was
redeemed. The Virgin was recalled by these
and other symbols of similar character, spread
from one end to the other of the Gothic
church. Even when she is represented in the
form of the Madonna with Child, as in the
famous *belle verrière* of Chartres, she is not
given the appearance of an earthly being. She
is lifted above the contamination of the world
and its materialism. There she sits with her
glowing colour, the most beautiful blue, per-
haps, which the hand of man has ever pro-
duced, radiant in glory, but the Queen of

Heaven, never for an instant a woman. Her attitude has the hieratical and symmetrical form by means of which the Gothic artists succeeded in lifting their figures above the earthly.

Let us compare with this treatment of the Virgin in mediæval art, the attitude of the Renaissance artists towards the same subject. Critics have spent many pages in descanting upon the spirituality of these Madonnas. As a matter of fact, however, the element of sensuality which is almost inseparable from that of human figures treated realistically, is most notably present. Let us look, for example, at the Madonnas of Andrea del Sarto. For one and all, the model was the artist's wife, the notorious Lucrezia, who, on the testimony of an eye-witness, Vasari, has gone down through the centuries branded as the type of the wicked woman, a faithless wife, an instigator to crime, selfish, remorseless, unscrupulous. These are the features which one of the most famous artists of the Renaissance gave to the Mother of God. When one thinks of the veneration which is often paid to pictures of the Virgin in Catholic churches, this use of the portrait of Lucrezia is singularly repellant. Nor was it rare for a Renaissance artist to take his mis-

tress as a model for the Madonna. It was on the contrary a common custom, practised quite generally. Fra Filippo Lippi, although a monk, used as his model the famous Lucrezia Buti — Browning's niece of the prior — whom he seduced. Botticelli, the enthusiastic follower of Savonarola, used the same model for his Madonnas and for his Goddesses of Pleasure. In which part she was more in character may be judged from the fact that she posed for Pier di Cosimo as well as for Botticelli nude, and according to a tradition — which is not intrinsically improbable — was the mistress of Giuliano dei Medici.

No, whatever else we say about Renaissance art, let us not speak of it any longer as spiritual. The Renaissance artists treated Christian subjects with flippancy too persistently to leave any doubt on the subject of their true feelings. An endless assortment of saints stand with the utmost composure and look with stony indifference upon the scenes of suffering at which they are present. The apologists of Renaissance art try to explain this method of treatment by calling it impersonality, and finding in it a quality much to be admired. Piero della Francesca has been especially praised as a leading exponent

of this impersonality. It would be more
exact to call it thoughtlessness and insincerity.
Critics are fond of speaking of the formulism
of mediæval art, but in mediæval art it was
not formulism, because it was alive and sin-
cere and genuine. In Renaissance art there
is much more formulism because the artists
were using subjects in which they no longer
believed nor were interested to cloak experi-
ments in technique or appeals to sensuality.
Could anything be more absurd than the
habit of the Renaissance artists of represent-
ing several different events in the same fresco?
The Sistine chapel is full of examples of this
abuse. In the same picture we see Moses
upon Mt. Sinai, the worship of the golden
calf, the breaking of the tables of the Law,
and other scenes supposed to be separated by a
considerable interval of time, yet all of which
are represented together in one muddled
composition, as if they were happening
simultaneously. It is clear in such pro-
ductions that the painter cared nothing for
his subject. The iconographic purport is com-
pletely sacrificed to the caprice of the artist
and to the real or fancied exigencies of his
technique.

The peculiar greatness of Gothic art, in so
far as it is susceptible of analysis, lies, I

should say, primarily in its other-worldliness. It is distinctly immaterial. In this it is the antithesis of Greek art, which is clear-cut, tangible, which contents itself with idealizing the beauty of the world. The godlike Homer raises us to the grass-grown ridges of Olympos, where Apollo stalks along, his silver arrows clanging in his quiver; but although Homer guides us to the mountain tops, he never lifts us into the skies. His Apollo, beautiful as he is, remains, after all, merely a glorified man. Certain poets, such as Goethe in the second part of "Faust," transport us into a dream-world, where forms of the earth are softened and transformed by a poetical mist into shapes of supermundane loveliness. Admirable are the achievements of such artists, and we seem, under their spell, to float in a vision of unreality. Yet these poets, too, in the last analysis, never really succeed in creating the atmosphere of another planet. We look, it is true, through fantastically coloured glasses, but the images about us are still mundane. The most difficult task which any artist can set himself in any medium is to express that of which the earth gives no prototype, to rise from the terrestrial to the heavenly, to create from his imagination the delights and emotions of

Paradise. Many have attempted this supreme task, and many have failed. Even Milton, in his " Paradise Regained," never for an instant rose to the height of his great argument. Fra Angelico might have succeeded, had it not been for his sentimentality. It is, to my way of thinking, only twice that man, who is forever tugging away at his own boot straps, has completely succeeded in imagining and expressing the conception of the other world. Once it was Dante, not in the " Inferno " or " Purgatorio," which are from every point of view inferior, but in the " Paradiso " alone; the other time it was the artists of the Île-de-France when they created Gothic art. Perhaps the finest line of criticism that has ever been written upon the mediæval church is that of Suger, abbot of Saint-Denis in the twelfth century, and himself one of the creators of the new style. When his abbey had at last been completed, the soaring vaults walled in, the windows filled with glass, he wrote: *Videor vedere me quasi sub aliqua extranea orbis terrarum plaga, quae nec tota sit in terrarum faece.* Just there lies the greatness of Gothic architecture. It is a mighty genius, a colossal imagination which has the power to transport us from the mundane to the supermundane, from the material to the

immaterial, from the tangible to the intangible.

There remains the ideal of obedience. The present is the age of the individual, the mediæval period was the age of the community. Obedience in the mediæval conception signified the renunciation of the desire to realize one's own personality in favour of the resolution to realize the ideal of the age. Thus all mediæval labour was bent towards the same end. The work was everything, the worker, nothing. We know the name of but few artists of the Middle Ages. These men who created such idyllic beauty had apparently little desire for personal glory. They left their work to rejoice future ages; but they cared nothing for handing down their names to posterity. They were glad to be forgotten, the work of art alone counted. How different is this from the modern point of view, where each individual works only for his own fame, his own glory, where every tenth-rate dauber signs his worst sketch in glaring letters!

A passage in the "Lives" of Vasari is singularly significant of this difference of point of view between the mediæval and the Renaissance artists. It occurs in the *proemio* of the life of Arnolfo di Cambio, and I am sorry to have to render it, as it is singularly difficult

to translate. In effect, Vasari, after having catalogued the great Gothic churches of Italy, and after having remarked that he had been unable to find out who were the architects, exclaims: "How boorish (*goffezza*) and how little desirous of glory were these artists, who took no pains to transmit to posterity their names!" Of course Vasari could not understand this, no more than he could understand anything else of the Middle Ages.

It is the same thing in regard to the donors. Occasionally in a Gothic church a modest shield, carved or painted in some out-of-the-way corner, will bear the coat-of-arms of a noble family or trade corporation. Almost never are portraits represented. In the typical Gothic cathedral we search in vain to discover who were the architects, who the painters of the stained-glass windows, who the carvers of the sculptures. It was very different in later times, when the windows bore, not images of saints and prophets, but portraits of rich lords and pompous prelates.

I cannot resist the temptation to turn back once more to the Sistine chapel to contrast, in this particular, the art of the Renaissance with that of the Middle Ages. At the papal court of Rome, the great centre of culture and learning in the fifteenth and sixteenth

centuries, we might, indeed, expect to find
artists working with a certain intellectual
finesse. We are not unprepared to see them
choose subjects less obvious and less hack-
neyed than those which they were using else-
where, and which even present more or
less the character of intellectual puzzles.
And such was indeed the case. Bearing in
mind the poetry of mediæval philosophy, the
intellectuality and sincerity with which the
mediæval artists glorified their God and their
religion in the provincial churches of far-
away France, let us now see what the Renais-
sance artists did in the private chapel of
Christ's Vicar on earth, the centre of culture
and Christianity. Botticelli painted in the
Sistine chapel, directly opposite the throne
upon which the pope sits when celebrating
the offices, a very famous fresco. Everyone
knows it, although but few are acquainted
with the subject. It is sufficiently obscure
and, I suppose, intellectual, so that it long
escaped all interpretation. A modern critic
has, however, discovered it. It is the illus-
tration of several verses in the book of
Exodus in which are described the Jewish
rites in connexion with cleansing the leper.
Why was this particular passage picked out
for illustration? It was because the pope who

was then reigning — Sixtus IV, I think it was
— had built in Rome the famous hospital of
S. Spirito for the lepers. The painter or
whoever selected the theme was, therefore,
paying a subtle compliment to the pontiff by
alluding to this fact. That was the reason
this particular subject was chosen. The glory
of God was a matter of no concern. In
this same picture, in the background, are
introduced three other scenes representing
the temptations of Christ. Was it for some
subtle theological or dogmatic connection that
these events of the New Testament were com-
bined with one of the Old Testament with
which they appear to have so little to do?
Not at all. The temptation of Christ was
introduced in order that the artist might
have the opportunity to represent the Devil
talking to the Saviour on the pinnacle of the
temple, and it was desired to show this temple
in order that the artist might depict it in the
architectural forms of the recently completed
hospital of S. Spirito, thereby again alluding
to the generosity of the pope and flattering his
patron. The same spirit breathes throughout
the decorations of the entire Vatican. The
work of Raphael in the famous *stanze* is per-
meated by it. The frescos one and all reflect,
not the praise of God, but the glory, the

[96]

temporal power, the princely magnificence of the popes. No secular princes ever vaingloried in their lineage and prowess as did these proud pontiffs of the Renaissance. At times the flattery of the artist becomes almost nauseating. Witness the " Incendio," the " Heliodorus," the " Attila," in which are represented historical events of sacred character or miracles, but where the introduction of the portrait of the reigning pope, Julius II or Leo X, makes it clear that the allusion is to contemporary events, the successful political intrigues, the land-grabbing and oppression of weaker states by the unscrupulous pontiffs. It was a singular idea to make Julius II and Leo X the most worldly, the most cynical of princes, masquerade as saints and heroes of sacred legend.

Such is the contrast between the spirit of mediæval and of Renaissance art. In one we have the glorification of God, in the other the glorification of man. Renaissance art acquired the human but it lost the divine.

Moreover, the spirit of obedience is manifested in the mediæval cathedral in an even more subtle way. There is no conflict between the different arts. Sculpture and painting are the dutiful handmaidens of architecture, lending their beauty to increase her

effects, and thus combining to make of the cathedral one complete and harmonious whole. This architectural restraint, far from being a source of weakness to the accessory arts, seems to have operated to stimulate them to great achievements. In the Renaissance, sculpture and painting, fired by the new spirit of individualism, rebelled from architecture. They must exist for themselves alone. It is not clear, now they are freed from architectural restraints, that they have become either more expressive or more decorative than before. In fact this declaration of independence has been the undoing of all three arts. Because of their insubordination, architecture has been obliged to do without painting and sculpture, the aid of which she greatly needs. Painting and sculpture have thus lost their best and most useful field of activity. To-day we have quantities of painters and sculptors, often not without talent, producing works, finely individualistic without doubt, but for which no one cares. Their labour adds not at all to the joy of the world. If it were only employed as formerly in the service of architecture, these minor artists might render a real service, at the same time finding a more adequate expression of their own artistic emotions.

The ideal of obedience is also reflected in
·the strong tradition of mediæval art. It is
the modern conception that the individual
should be left free to the last degree to develop
his own nature; that the artist should be
untrammelled by any laws and conventions.
In the Middle Ages, on the other hand, the
spirit of the time was so strong that an in-
dividual never emerged above it. In the
Gothic cathedral we seek almost in vain to
discover the hand of any one man of super-
lative excellence. Such a system seems to us
to cut the wings of genius, to prevent flight
into the highest altitudes. We think of it as
sacrificing the exceptional few to the mediocre
majority. If, however, we apply that prag-
matic test upon which the modern world lays
such weight, we shall be forced to recognize
that no individual modern has achieved greater
artistic excellence than the collective Middle
Ages. In addition there is a singular evenness
of attainment in mediæval art. The thirteenth
century not only produced a few buildings
which equal the best produced at any other
period, but everything executed at that time·
was on nearly the same level of excellence.
The strength of the mediæval tradition, the
force of the spirit of obedience was such that
all artists were carried along with it. No one

could produce bad work. To the individu-
alist of the twentieth century this condition
of affairs is unthinkable. Yet the fact remains
that in the Gothic period the most remote
country churches, the most insignificant build-
ings, show the same exquisite detail, the
same unerring sense of beauty as the great
cathedrals.

Thus the mediæval builders pursued their
strange ideals of poverty, chastity and obedi-
ence. Small wonder the materialist modern
shrugs his shoulders and passes on.

FRENCH GOTHIC AND THE
ITALIAN RENAISSANCE

DURING the Middle Ages the domi-
nant influence in western art was the
Gothic of France. This fact is so familiar
that the statement borders upon banality.
The generalization holds even in some ap-
parent exceptions. If France borrowed the
Flamboyant from England, she nevertheless
gave the style its distinctive character, and
passed it on to other nations in a French
guise. It is hardly an exaggeration to say that
from the twelfth to the fifteenth century, the
superior excellence of the French manner
was acknowledged throughout Europe, from
Sicily to Scandinavia, from Ireland to Hun-
gary.

It has, however, generally been assumed
that the influence of Gothic ended with the
Middle Ages, and that Renaissance art sought
its inspiration in other sources considered
more pure or more troubled according to the
critic's angle of vision. Scholars have almost
entirely overlooked the very deep influence
which the French Middle Ages exerted upon

the art of the Italian Renaissance. It is, indeed, a curious paradox that a period which seems the antithesis and negation of Gothic should, nevertheless, owe to its despised predecessor essential features of its greatness; so curious, indeed, that the point may be worth investigation in some detail, even at the risk of falling into that most slippery and sticky of bogs, analysis of style.

Fortunately, however, not all our way lies through this swamp. French mediæval influence was exerted upon Italian Renaissance art not only through the borrowing of artistic motives, but also through the borrowing of philosophic ideas. French scholasticism had held in Europe as preëminent a position as French architecture. It was, indeed, the force which more than any other had moulded mediæval art. In the Gothic cathedral architecture and philosophy had been inseparably entwined. European art in the Middle Ages was, therefore, deeply influenced by French scholasticism, and in Italy continued to be so influenced throughout the Renaissance.

No conception was more characteristic of scholasticism than that of the sibyls. For the mediæval mystic the entire world was imbued with symbolism. In every detail of nature God had written the solution of the enigma of

the universe, if man would but read. If the dove has red feet, it is because she signifies the Church which advances across the centuries with feet bathed in the blood of martyrs. The nut of which the shell is hard as the wood of the cross, but of which the inner meat sustains the life of man, is the image of Christ. The Old Testament is the transparent shadow of the New; David and Solomon, Adam and Isaac figures of Jesus. Pagan literature was interpreted in the same spirit. The "Iliad" of Homer, the "Metamorphoses" of Ovid, became profound allegories of Christian truth. Of all pagan figures the sibyls lent themselves most easily to such imaginative poetizing. There was about these strange beings, half women, half goddesses, a grandeur, an aloofness which had baffled antiquity itself, and which made them seem to the Middle Ages worthy companions for the Hebrew prophets. According to M. Mâle, a rôle in the Christian drama was first given to the sibyls by St. Augustine, who put into the mouth of the Erythræa an acrostic poem on the Last Judgment. The sibyl was conceived by the author of "Dies Irae" as ushering in cheek by jowl with David, amid ashes and destruction, the final evening of the world:

Dies Irae, dies illa
Solvet saeclum in favilla
Teste David cum Sibylla.

The Gothic artists did not hesitate to make
for the sibyl a place beside the most authenti-
cated Hebrew kings and prophets. Surely
the temple of paganism was never despoiled
of a grander or more striking column for the
adornment of the Christian church.

The austerity and power of the mediæval
sibyls fascinated the Italian Renaissance.
Castagno's "Cumana," which seems sculptured
in flint, is but an attempt to express, in terms
of the concrete and near-sighted Quattro-
cento, the unbounded vastness of a Gothic
ideal. Definitive expression was given these
pagan prophetesses by Michel Angelo who
sealed them with immortal beauty. How
much of the stormy grandeur of the Sistine
is due to the iconographic conception of the
sibyls, which the Titan of the Cinquecento
was so well able to represent, but which he
or any man of the Renaissance would have
been powerless to invent!

Michel Angelo's "Last Judgment" is
equally inspired by mediæval thought, in part
tempered by the fire of Dante, in part mined
directly from its native rocks. The author
of the "Dies Irae" had already conceived

the relentless, avenging Christ—*rex tremendae majestatis* — although without the physical violence, the convulsive corporeal energy which Michel Angelo portrayed. It is unfortunate that the painter took his inspiration from literature rather than from the Gothic artists. Mediæval sculptors, in fact, had attained in their representations of the Last Judgment heights to which they hardly rose in the treatment of other subjects. They were wiser than Michel Angelo because they wove together many moods to form a single symphony. A colour scheme gains force by the introduction of extraneous tints, and a piece of music will be more overwhelming if softer passages are introduced in contrast with the climaxes. In the "Last Judgment" of Bourges, terror is unquestionably the prevailing note — terror inspired by the gaping tombs, by the rising of the dead, by the malevolence of the fiends, by the tortures of the damned, by the jaws of Hell. But the feeling of horror is heightened by contrast. The Christ who shows His wounds, even while alluding to His own sufferings, is not without sympathy for those of others. For all His sternness, He is approachable, as not even Fra Angelico at Orvieto was able to paint Him. The Virgin and St. John intercede

for sinners, not entirely without hope of success. Abraham with real benevolence receives the souls of the blessed to his bosom. An angel, openly delighted, lays his hand with inexpressible tenderness upon a soul who has been weighed in the scale of justice and not found wanting. Neither Christ nor his ministers know Michel Angelo's exulting joy in the infliction of punishment. And in the voussoirs sing in triumph the choirs of the heavenly host, celebrating the victory of the blessed. The mediæval conception is more convincing, less exaggerated, of finer grain. Michel Angelo's work is like a piece of music orchestrated only for trombones.

There is something of the same monotony in Signorelli's frescos at Orvieto which form the most complete chronicle in art of the ending of the world. It is only in the ceiling that contrast is attempted, and even here rather grudgingly. The previous work of Fra Angelico forced the Cortonese to devote this space to the choruses of patriarchs, prophets, apostles, martyrs, virgins and doctors; but those which he painted are executed in a dry manner that makes them seem almost as joyless, and certainly more bored, than the seething masses of the damned below. Hell and Paradise are passed over

swiftly, each being crowded into the half of an awkward lunette, most of which is occupied by an opening; it seems as though the artist had purposefully suppressed, so far as he dared, both, in order that he might not be forced by logic to dwell more than he wished upon the delights of Heaven. Similarly Purgatory with its element of hope interested him but little. It is represented by means of small monochrome medallions, depicting scenes from the opening cantos of Dante's description, hidden away among the exquisite vine- and scroll-work of the dado. The scenes of terror, on the other hand, are developed with extraordinary amplitude. The mediæval legend is elaborated with a fulness of detail Gothic artists had never attempted. Act by act the dreadful drama unfolds. The cosmic upheavals which shall announce the ending of time — fire, flood, earthquakes, pestilence, war; the coming of the Anti-Christ, his miracles, his horrid preaching, lawlessness, murder in the world; the blowing of the trumpets, the opening of the tombs, the resurrection of the dead, ghastly skeletons clothing themselves with the nude flesh of perfect youth; the elect separated from the lost; the damning of the damned. The curtain falls on a divine tragedy of hate.

Although treated in a completely Renaissance spirit, the Orvieto frescos are founded upon the Gothic epic. Without the basis of the legend Signorelli's achievement would have been impossible.

Indeed, the debt which the Renaissance owes to the Middle Ages for having supplied the subject matter of its art is incalculable. Quattrocento artists were constantly drawing upon the rich stock of mediæval lore. In the cloister of S. Maria Novella a follower of Castagno painted the blind old man Lamech, led by Tubal-Cain, shooting with his bow and arrow the aged and wicked Cain skulking in the bushes. Not only the Hebrew Apocrypha but the legends of countless later saints had been touched with gold by Gothic poetry. Renaissance artists often chafed at the limitations imposed upon them by tradition. When freed from this restraint, however, their achievement, instead of soaring to greater altitudes, like Simon Magus fell. The Council of Trent, in signing the death-warrant of Christian mythology, gave the *coup de grâce* to art. The Renaissance only stood, because built on the solid foundations of the Middle Ages.

The spirit of St. Francis himself is thoroughly French. Indeed it is incon-

ceivable that such a character could have existed in Italy had it not been for the influence of the scholastic thinkers of France. Italy, before the coming of French influence, had in matters pertaining to religion tended to be indifferent, even sceptical and flippant. There is no trace of mysticism, of scholasticism, of philosophy worthy of the name before the first half of the twelfth century. French influence poured in, and St. Francis of Assisi was born.

Before the coming of French influence, the Madonna was comparatively little worshipped in Italy. It was the French who developed the cult of the Virgin, surrounding it with the poetry of legend, and glorifying it by the beauties of art. Without French mediæval thought the world could never have possessed that series of Italian Madonnas beginning with the Rucellai and culminating in the visions of Botticelli.

Equally striking are the artistic borrowings of Renaissance Italy from mediæval France. Several features of Brunelleschi's architecture are derived from French Gothic. The compound piers of his churches such as S. Spirito at Florence, though treated with classical detail, are a Gothic feature. The continuous reveals of his windows, doorways

and arcades, the most characteristic decorative mannerism of his style, were simply an adaptation of the continuous mouldings of French Flamboyant. The famous borders to Ghiberti's doors of the Baptistery of Florence, with the charming and naturalistic imitations of flowers and beasts, are a literal copying of the type of ornament that had been evolved by the Gothic artists of France. The quatrefoils, in which are placed the reliefs in the celebrated doors of Ghiberti and Andrea Pisano, are a motive taken from Gothic edifices of France at least a century earlier in date. The shape of the panels is only slightly altered from those of the façade of Amiens, filled with works of plastic art even more compelling in beauty, and is precisely the same as that of certain medallions in the ambulatory windows of Sens.

But it was especially in sculpture and in painting that the Italian Renaissance depended upon the French Middle Ages. It is recognized that the men who did most to form the art of the Renaissance were the two sculptors, Giovanni Pisano and Donatello. Giovanni Pisano's contribution to the artistic progress of the period was line; that of Donatello was realism. Now Giovanni Pisano's line and Donatello's realism were both in-

spired and made possible by the Gothic art of France.

Let us take up the question of realism first, since it may seem incredible that the great sculptor of the Renaissance should have owed, even indirectly, his art to the North. And to begin with, the reader must agree that the value of realism in art has generally been over-estimated. For four centuries the imitation of nature has been the chief and often the sole ideal of artists, and exactly those centuries have in general been a time of precipitate artistic decline. The value of pure beauty, of illustrative beauty, of decorative beauty, of beauty which is not necessarily any direct imitation, least of all any realistic representation of natural objects, has been overlooked. That is the reason, perhaps, that decorative art has largely gone out of the world, and that we have no longer objects of utility such as furniture, wall-paper, stuffs or household articles, which are also works of art. The Middle Ages thoroughly understood decoration. The mediæval artist felt it to be quite immaterial whether or not he attained naturalistic representation. He was generally content with beauty, and cared little whether his figures produced illusion. The modern artist cares chiefly whether his figures pro-

duce illusion, and too often is indifferent whether they be beautiful.

Until the twelfth century mediæval art contented itself with pure and abstract beauty such as it could attain. There was much study of design and of decoration, but there was little realism. But in the second half of the twelfth century the French artists of the Île-de-France began to turn to nature, preserving, however, their sense of design, their feeling for pure beauty, derived from long centuries of schooling in the field of conventional art; they took the forms of nature, selected with an artistic tact that has never been equalled those which of all others most happily lent themselves to the particular purpose in hand, conventionalized them just as far as was necessary. This process was first applied to purely architectural numbers, especially to capitals. The plant forms selected were the bulbous ferns, the graceful and slender flora of the early spring. The Romanesque abbey, austere and sublime as the winter, suddenly burst into the spring blossom of Gothic.

This was the first step towards naturalism and realism in the long and steady evolution that has gone on from the twelfth century to the present day. And mark how radical a step it was. Architecture would seem the least

imitative of the arts. The natural acanthus is said to have inspired the classic Corinthian capital; it almost certainly did not; but even if it did, all feeling for nature, all realism, was long ago crushed out of the motive. Except in the Gothic period, architecture has always been unimitative. Even in the Italian Renaissance, when men were going mad on realism, architecture remained conventional. We seek in the buildings of Palladio and even of Bramante in vain for one touch of the imitation of nature which bore so fair a flower in Gothic art.

The Gothic capital was the first step towards realism. *Facilis descensus Averno.* The naturalism which had begun in so charming and delicate a manner was carried by the fourteenth and fifteenth centuries even in France to extravagance. In the capitals and string-courses the imitation of nature became ever more exact, the conventionalization less, the total result more restless. Nothing could be greater than the delicacy with which the Flamboyant architectural foliage is carved; nothing more tender than the love with which each detail is observed and studied. But the beauty of the building as a whole has been lost in the elaboration of the parts.

From architecture realism soon spread to

the sister arts of sculpture and painting. In the twelfth century, as, for example, in the western portal of Chartres, the artists had carved statues chiefly with an eye to beauty. Soon after, the study of nature entered. In the northern transept of Chartres in the early thirteenth century we find more naturalistic proportions, more realistic features, draperies that are far more real; but still the ancient beauty, the sense of design, the feeling for decoration survives. At Reims in the second half of the thirteenth century, realism has already become dominant. There is no longer rigidity in the pose of the figures — they move freely, place their weight now on one foot, now on the other, turn as do living human beings.

As time went on the sculptures became more and more naturalistic. Along with decorative significance departed also illustration and sincerity. The art is no longer charged with the intellectuality of earlier times. The artist forgets Christ in his intense interest in the wrinkles and moles of the peasant who serves as his model.

Stained glass underwent precisely the same evolution. The figures of the twelfth century, grand and hieratic, charged with symbolism and intellectuality, glorious in colour and

decorative quality, begin to show in the thirteenth century the study of nature. Later the figures become less rigid, more life-like. Mary, who in earlier works had stood impassive, impersonal, a symbol beside the cross, swoons at its foot. Sentimentality goes hand in hand with realism. In measure as the study of nature supplants the study of beauty, the colours become softer and weaker, the design less vigorous — in short, both illustration and decoration decline.

Now with these naturalistic tendencies of French mediæval art the Italian artists of the Renaissance were well acquainted. From the middle of the twelfth until the fifteenth century Italy, like the rest of Europe, had been the obedient follower of France in matters artistic. French methods, French ideas, French designs, were carefully studied and closely imitated. Donatello, therefore, could not have failed to be aware of French realism. When he set himself the task of studying nature as his purpose in life, there is little reason to doubt that he derived his inspiration by some means from France. We thus see that French mediæval art is at the basis of what superficially seems most antagonistic. To it we owe the study of nature in the Renaissance, the art of Masaccio and of

Michel Angelo. In fact, to it we owe all modern art.

In the case of Giovanni Pisano the influence of French mediæval models is so clear and unmistakable that it has been universally recognized even by critics who had little familiarity with Gothic work. His father, Niccolò, is given much importance in the hand-books of Italian art, especially those of the machine-made variety, as having instituted the classical revival. In point of fact he did nothing of the kind. The imitation of antique fragments had been going on in Italy long before his time, not only in architecture but in sculpture as well, as is evident, for example, in the Baptistery of Florence or the reliefs of the façade of Modena. Niccolò Pisano was a very indifferent artist. He is inferior to contemporary sculptors of France and even to the twelfth century sculptors of Lombardy, in composition, in feeling for beauty, and, in fact, in almost every true requisite of plastic art.

With his son, Giovanni, the matter was different. Giovanni was trained under unfortunate auspices, and his early work executed in connexion with, or under the influence of, his father shows many of the latter's faults in confusion of composition and vul-

garity of detail. However, Giovanni's own genius soon asserted itself. He turned from the turgid art of Niccolò to the limpid beauty of French Gothic, became French in spirit, as thoroughly and completely French as if he had been born and brought up in the ateliers of Paris.

Now, as we have said, not Niccolò but Giovanni Pisano was the great formative artist of the Italian Renaissance. Giovanni was the man who blazed out the path that subsequent sculptors and painters for two centuries were to follow. And the great work of Giovanni was that he introduced from France the study of line. Until his time the beauty of line had hardly been known in Italy. The French, however, had perfected it. In many works of sculpture, such as, for example, the tympanum of the Cathedral of Senlis, the Gothic sculptors of France had developed line, to its utmost possibilities. From such compositions as this Giovanni Pisano took his line, which he passed on to the entire Tre and Quattrocento. Now it is this French line which forms the chief merit of the greatest artists of the Italian Renaissance. It is line which sweeps us off our feet in the New Haven Bernardo Daddi, for me, one of the greatest Italian pictures in America. It is

line, "singing line" as Berenson calls it, which makes unforgettable the "Annunciation" and the "Guidoriccio" of Simone Martini. It is line that wins us in the transcendent Neroccio of the Yale gallery. It is line that gives to the works of Botticelli that indescribable sweetness and languor which fascinates as does the taste of some exotic fruit. The spirit of Botticelli is essentially mediæval. His drawings for Dante, in which perhaps more than in any other work the inmost character of the artist is revealed, are as far removed from the tactile values of Masaccio as they are akin to the mysticism of the Middle Ages. Nor was the French spirit in the Italian Renaissance limited to these examples. It would be easy to follow it, permeating, conquering almost every artist of the Quattrocento. The "Ilaria" clearly shows this French influence. Indeed, so patent is it, that the latest student of the monument, Mr. Marquand, inclines to believe the sculpture actually the work of a French artist. The same French influence breathes in the gracious sweeping lines of the Civitale, now in the Metropolitan Museum, a monument not unworthy to be compared with the "Ilaria" herself for decorative content.

It is therefore clear that to the already

[118]

recognized sources of the Italian Renaissance
we must add French Gothic, and that we must
ascribe to it some importance. The share of
the classical revival has already been greatly
diminished by the demonstration of the fact
that the Gothic and especially the Roman-
esque of Italy formed the basic element out of
which was created the new style. This share
must now be still further reduced. The singu-
lar fact also appears that when France in the
sixteenth century took the Renaissance from
Italy, she was in reality but receiving back
what she herself had at least in part given.

THE ART OF GIOTTO

CHARACTERISTIC of this America of ours are the waves of fashion that sweep through the country. There is danger in this jerky, intense way of doing things, even when the excitement is directed towards some object in itself entirely laudable. The wise man, the strong man, does not take up a purpose with terrible seriousness one hour to forget about it the next. We attack amusements, charities, politics, religion, literature, germs and art in the same nervous unsteadfast spirit.

It is therefore with very mixed feelings that we must regard the rise in the field of art of a distinct fad for Italian primitives. We may concede at once that the present popularity of the Giotteschi in many ways gives cause for optimism. It is impossible not to feel that a taste for Giotto, if sincere, represents an immeasurable intellectual and artistic advance over the taste for Barbison and Fragonard, which it supplants. There is great satisfaction in seeing that the mantle of Elijah which our grandfathers wrapped about the

slippery shoulders of the Eclectics, and which our fathers passed down to Raphael and Michel Angelo, has by the present generation been bestowed upon the great master of the Dugento. It is a wholesome sign that the term "Giotteschi" should be as much used and abused in current art jargon as was the term "Pre-Raphaelite" in the nineteenth century. Even the word "Pre-Giottesque" is coming to have an almost hackneyed sound. Cimabue has emerged from that grey-green mysterious twilight in which he sat shrouded by the legends of Vasari; the speechless mysterious sphinx of rigid limbs and inscrutable aspect, unapproachable as an Assyrian goddess, has resolved herself into the gracious Madonna of the lower church at Assisi. Mr. Kahn's "Cavallini" shrinks within herself, looking with great reproachful eyes upon the ugliness of the new world, as if half hoping, half despairing of mitigating its banality by the presence of her own incomparable loveliness. All this we cannot but see with the greatest pleasure. Yet American fads have a dreadful way of blighting and befouling all that they touch. The swarm of locusts flies away leaving the verdure sere, the flowers deprived of their freshness.

At least it must be admitted that fashion

in her arbitrary and unreasoning pickings and choosings could hardly have chanced upon any figure in the history of art whom age has so little power to wither or custom to stale. Modern criticism, which has pulled down many temples about the heads of false gods and has unseated ancient despots of the world of art, has merely strengthened the throne of Giotto. Closer study has changed even radically our conception of the master, and has swept away many venerable fables and misapprehensions, but the figure of the artist emerges only the more commanding. Dr. Sirèn's recent researches have enriched the Metropolitan Museum with an accredited and hitherto unsuspected work of the master, but have also relieved him in part of responsibility for the famous cycle of frescos, numbers 2 to 20, at Assisi. The latter, dealing with the life of St. Francis, have been accepted heretofore as an early work of the artist, and include such panels as that of " St. Francis preaching to the Birds," which possibly more than any other painting has represented Giotto in the popular conception. The entire cycle now appears to be the work of Cavallini and his pupils, of whom Giotto was merely one.

The fact that such confusions have been,

and still are, often possible, demonstrates a truth so frequently brought out by modern criticism that one wonders the critics themselves have failed to grasp it. The difference between the great masters, their predecessors and followers, is so slight as to be nearly imperceptible. The keenest critics, with the aid of documentary evidence and the most subtle technical analysis, are frequently unable to determine which paintings are, and which are not, by the man with the well known name. It follows as a necessary consequence that there is no such great gulf fixed between the master, his predecessors and his followers, as connoisseurs for centuries have been disposed to believe. A rose by any other name would smell as sweet. The Assisi panel of " St. Francis preaching to the Birds " remains one of the world's masterpieces of mural decoration whether it was painted by the great Giotto or by an unnamed and obscure follower of Cavallini. The " Nativity " of the Metropolitan Museum should have given us as keen pleasure before Dr. Sirèn christened it a Giotto, as now that it has become one of the most prized possessions of the Museum. The very critics, who proclaim most loudly the superiority of Giotto over other artists of his time, are constantly mistaking works

of minor painters for productions of the master.

This worship of names has ever since the thirteenth century been one of the great curses of art. There has been a continuous tendency to give because of the name of the artist a fictitious, not a true, value. It results perhaps from a certain mental laziness that, instead of making our own valuations, we are ever eager to take them ready-made. The same mental stupidity causes the success of advertising. There is not one of us but who, by intelligent effort, could discover the type of breakfast food he likes best. Do we make this effort? Far from it. We meekly allow the inferior variety to be forced down our throats by clever manufacturers who advertise until we become familiar with the name. The same thing has happened in art. The advertising, it is true, has been done less crudely than in the case of breakfast food, but has nevertheless existed ever since the fourteenth century, and has continually become worse. It was, moreover, introduced by Giotto. Although Romanesque sculptors had occasionally not hesitated to extol their own wares, Giotto was the first individual since Roman times (except possibly Cimabue) who succeeded in imposing his name upon the world of art. This pre-

eminence came to him, doubtless, in no small part through the famous lines of Dante, which would have sufficed to give him immortality, even had no example of his painting survived. We have, therefore, in Giotto the first great name in art, and in Dante the first of the critics. This was the beginning of a vicious system of ready-made values, which has been carried to incredible lengths by the present age.

There is, I think, one truth we may safely deduce not only from the study of art but from the observation of all human and natural phenomena about us — the comparatively little importance of the individual. In the Middle Ages the individual hardly existed apart from the community. In Renaissance and modern times he has assumed lamentable prominence. Now Giotto was one of the first individualists, he was one of the first to arrogate to himself a position and supremacy among his fellows, disproportionate, I do not say to his merits, but to theirs.

I think it must be obvious upon careful consideration that every man is essentially of his own time. The art of Giotto as it has come down to us is less a product of his own individual genius — great as that indubitably was — than that of the age in which he lived.

Had he been born in the sixteenth century he must inevitably have painted in the manner of the Eclectics; had he lived at the present day he must necessarily have painted as do our modern artists. We may grant that his art would have been better than that of any Eclectic or of any modern, but it is inconceivable that he could have possessed even in small part the merit which he actually did possess. The force of the community must in every instance be inevitably greater than the force of the individual. If there is no artist living at the present day whose work can stand beside that of Giotto, the fault lies not with the individual artist but with the age. If the Dugento had not produced Giotto, it must inevitably have produced someone else who would have done his work. The century which brought forth the Gothic cathedral and St. Francis of Assisi — perhaps the two grandest products of human civilization — was predestined to produce what should destroy the work of both. In Cimabue, Cavallini and their school we see developing an evolution which slides into the art of Giotto so gradually, so softly, that perhaps no man may say precisely where one ends and the other begins. On the other hand the art of Giotto slides into that of his followers and

disciples as smoothly, as inevitably. There reigns, for example, the utmost uncertainty as to whether Giotto or some assistant or pupil painted the Magdalen frescos at Assisi. Giotto therefore really occupied a central position in a tendency which began long before his time, and continued as long after his death. The old legend of Vasari must consequently be discarded. Giotto no longer appears as a heaven-sent minister of genius who created the sweet new style with a single stroke of his brush. This flaming, heraldic figure standing on the first page of all histories of Italian painting is mythical. We now know that Italian art existed long centuries before the birth of Giotto, and many of us have come to feel that he represents not its birth but its culmination.

When all is said and done, then, we find that the first individualist Giotto was, like most of the individualists who followed him, not an individualist at all, but merely a necessary product of his time, and that his great name rests very largely, not on his indubitable merits, but on an importance which has been erroneously attributed to him.

Nevertheless, back of the legend of Vasari as back of most legends, there does lie an element of truth. Giotto stands at the turn-

ing of the way. With him we reach the crest of the pass. All that had been ceases. The course of art at this period is like a road across a mountain pass. At a given point the up-grade becomes down-grade, the waters which had been flowing south commence to run north, and yet we are always following along the same road in the same direction, develop-ing the same tendencies.

To appreciate the error of Vasari in its true enormity we must bear in mind two facts: the first is that the present is an age of artistic decadence, and the second that the fault for this lies very largely with Giotto. Both state-ments may require explanation.

The artistic decadence of the present time is an ungrateful subject. Sour-mouthed prophets have never been beloved, and least of all when they have told the truth. Yet the situation is so extreme and alarming that it ought to be faced squarely. The starting point for constructive artistic advance in America must be destructive criticism.

Take modern furniture, for example. Never before have household articles been manufactured so absolutely without charm and without beauty. Our furniture manu-facturies after having run through an orgy of horrors have finally abandoned the attempt

to create their own styles. They are content to copy anything antique. By this very fact they acknowledge their decadence. There is a great deal of difference in old furniture; some of it is better, some of it worse, but none of it is as bad as the modern reproduction. Place the copy beside the original and you will see to what depths we have fallen.

Even more striking is the decadence in china. Among modern designs offered for sale at fabulous prices in the Fifth Avenue shops, one searches almost in vain for a single one that shows a sense for either composition, colour or decorative effect. Placed beside the products of the same art in the eighteenth century, they show a decline from the good manner more sharp and more alarming than any from which Roman art suffered at the epoch of the barbarian invasions. The disquieting part about this modern china is that our people as a rule are entirely oblivious to its dreadfulness. They buy it in quantities, when really good pottery might be had for the same price or less. They eat off it three times a day, and allow their eyes and sensibilities to be corrupted without ever realizing its machine-made hardness, its sentimentality, its vulgarity.

Even worse is the case with silverware.

BEYOND ARCHITECTURE

Before the war I was often fairly appalled in examining the gifts commonly accumulated at a wedding. How in the name of reason has the human mind been able to conceive of such designs, to assemble so many examples of all imaginable ugliness! How can people who pretend to refinement and good breeding endure the possession of this mass of articles which has no other usefulness than the vulgar and ostentatious display of wealth? Such things could not be, if long custom had not blinded our eyes to lack of beauty. Nor would we otherwise be able to endure the insipidity of modern jewelry.

The Christmas festival is undoubtedly the greatest holiday we have in America. It is a time of excited delight for children, whose pleasure is frequently less keen than that of their elders. How do we celebrate this happy season? In the first place by decorating our houses with red and green, which probably of all possible colours and combinations of colour are the most jarring and discordant. Then we take a Christmas tree which as it grows in the forest is an object of singular beauty and poetry. We adorn this no longer with candles but with electric lights, undoubtedly one of the most detestable of all modern inventions. These electric lights are frequently coloured

the most poisonous shades of red, blue and
even green. As if this were not enough we
proceed to cover the tree with all sorts of
tinsel and trinkets, sentimental wax angels,
terrible glass ornaments, everything which is
glittering and vulgar. This is the great treat
which we have for our children. We teach
them how pretty it is, and how the joy of seeing
this wonderful object is the great event in the
entire year. If we were not æsthetic idiots,
would we not save ourselves the pain of be-
holding this dreadful object? Would not a
conscientious realization of the fact that we
were ruining the æsthetic perceptions of our
children cause us to discover some means of
celebrating the festival by means that were
equally joyous, without being hideous?

It is perhaps unnecessary to push the point
further. He who takes the pains to look, will
soon perceive that our life is surrounded by
ugliness as has been the life perhaps of no
other civilized people in any age.

Architecture gives us a clue to one of the
underlying reasons for the degeneracy of the
modern artistic intellect. We Americans once
possessed a good architecture. The buildings
of the Colonial period, and especially those
erected at the end of the eighteenth and the
beginning of the nineteenth century were

often full of charm and dignity. It is of course true that some were bad, and many indifferent, but the general average was highly satisfactory, certainly much better than anything we have since attained. The Colonial period was succeeded by the Greek revival. Then good architecture came to a sudden end in America about the year 1850. The cause is not difficult to find. It was the machine which crushed out handwork, it was the machine which killed beauty. The Neo-Grecque house, of good proportions and dignified detail, gave place in turn to the Victorian or wholly evil dwelling, adorned with lathe work, turned balustrades, little cupolas, scroll gables, incredible gingerbread of every description.

The machine killed architecture in America, not only because it killed handwork and because it substituted quantity for quality, but also in a more subtle way. It changed the ideal, the nerves, the entire nature of our people. It is an eternal truth that to think highly one must live simply. Our people ceased to live simply. Life became ever more complex, ever more agitated. Prosperity entered at the front door, and thoughtfulness, poetry and repose were forced out at the back.

Now this brings us to the great indictment

to which Giotto must answer. He, or rather the age of which he is typical, represents the introduction of the modern spirit. He was the first of the materialists, the first to place the tangible above the intangible, the worldly above the supermundane. It is the spirit of Giotto that has been working on this planet of ours for the last six centuries, and that has brought the world where it is to-day.

I believe it is not necessary for me to turn aside to point out how completely that school of critics which harps upon the spirituality of Giotto, is in error. It is strange that such sentimental nonsense should still continue to be repeated. The psychological attitude of the master is evident enough from the internal evidence of his paintings, which show the hard-headed, matter-of-fact, sensible man, interested in the solution of practical problems, eager to see things as they are, without sympathy for the poetic mysticism, the imaginative fervour of the Middle Ages. The matter is made even more obvious by Giotto's poem. The " Canzone sopra la Povertà " might have been written by a brilliant materialist of the nineteenth century. It is an incisive satire against idealism, as clear-cut and relentless as a lawyer's brief. It would hardly have been possible to find a man less suited by tem-

perament than Giotto to comprehend the spirit of St. Francis. It is one of the tragedies in the history of art that he was selected to paint the Franciscan legend. To speak of the religious feeling in Giotto is like talking of the Catholicism of Martin Luther. Compared with some of our modern divines, Luther approaches more closely the Catholics, because, for example, he believed in the Devil and Hell. Compared with later painters, Giotto showed the survival of numerous traditions of the Middle Ages which give his work superficially something of a religious aspect. In point of fact, however, Giotto bears the same relation to the religious art of the Middle Ages that Luther bears to the Church of Rome. His art in essence is in the highest degree materialistic. He it was who started the search for material truths. His was the spirit of investigation upon which rests all modern science. His successors in the Florentine school followed in his footsteps; they were primarily one and all scientists and investigators of physical phenomena.

Now although I hold Giotto largely responsible for the introduction of the gospel of materialism which has led to such dire results, I should not wish to be understood as disparaging the value of his contribution to the

thought of the world. After all, truth and
even material truth, is one of the most vital
and useful of all things. If we can only really
see the truth in any matter, however humble,
we have made a great step forward. All prog-
ress in the technical arts has been founded
primarily upon the accurate observation of
fact. The acquisition of fact is, and always
has been, and always must be, one of the chief
pursuits and the greatest triumphs of man.
It is because our knowledge of facts is only
partial that we are men, not gods. The curse
of human destiny has been that man is so often
unwilling to accept fact even when it is
accessible to him.

I am sorry therefore that the modern world
has learnt only half the lesson taught by
Giotto and his successors. We have accepted
the scientific part of the teaching; we have
learned how objects possessing three dimen-
sions may be represented on a canvas possess-
ing but two so as to produce even more vivid
retinal impressions. We have learned the
science of perspective in all its intricacies
and refinements. We have learned the theory
of shades and shadows and a thousand details
of drawing and technique. All this science
we have taken over from the Italian Renais-
sance. But modern art has forgotten the other

and no less vital part of the teaching — psychological truth. This cannot, perhaps, be better illustrated than by comparing Pintoricchio's portrait of Alexander VI in the "Ascension" of the Borgia apartments with almost any modern portrait. No one who has seen the painting of the pope will ever forget it. The character of this most decadent of pontiffs is as clearly drawn by the artist as in the page of history. The portrait of Dorian Gray never told half so plain a story. Sensuality, greed, brutishness, are written in characters that no one can mistake. How dared Pintoricchio paint such a picture? Why did the pope allow it to descend to posterity? It is clear that in that age men were not afraid of facing the truth. The painter recorded truthfully, without flattery, what he saw. To-day we are almost ready to forgive the pope for all his vices in return for the frank honesty which made such a portrait possible. You will search through Quattrocento art almost in vain for an instance in which the painter has sought to flatter either the character or the features of the sitter. These pictures are great because they are psychologically true, because they are an honest record of observed fact, because they retain the vitality and personality of the sitter. Turn from them to a

modern portrait (I except only those by Sargent), let us say of a society woman. Instead of a record of fact we find intentional deception. The one desire of both painter and sitter is not to look truth in the face. If there is some unfortunate feature, the face is turned so as to conceal it; if the woman is ugly, she must be made to look pretty; if old, she must appear young. Even more shocking is the wilful perversion of character. The continual effort of our modern artists and the continual effort of our modern sitter is to bring into the world a portrait which will represent the sitter not as he actually is, but as he would like the world to think him to be. What a sad commentary upon our twentieth century ideals these portraits form! How dreadful these women are! The shallowness of that pretty face, the inanity of the smile, the lack of character in the whole production will leave to posterity which they think so easily to deceive, a terrible record of uninteresting vacuity.

The same spirit of untruthfulness has permeated our architecture. The Gothic builders followed consistently the Lamp of Truth. All that the modern age has discarded. Imitation materials, false construction, columns which do not support, concealed

steel frames are the very alphabet of present-
day architecture. In fact, in only one thing,
so far as I know, are the New York archi-
tects honest — that is, in their bath-room
windows. As I walk the streets of the city,
the one feature of the inside of the building
that I see expressed externally is the bath-
room. There they are, row after row of small
windows, one directly above the other, follow-
ing the lines of the plumbing, and tri-
umphantly proclaiming to all the world the
nature of the apartment which they ventilate.
Even here, however, in this one apparent
frankness, we have a lie. The bath-room is
the one room in the house in which plenty
of ventilation, plenty of light and plenty of
air are imperatively needed. We therefore
make the windows for this room of about one
quarter the size of the windows for the
rest of the house. *Vanitas vanitatum, omnis
vanitas.*

It is not because he studied truth, nor even
because he studied material truth, that we
quarrel with Giotto, but because he neglected,
in his passionate search for the visible, prin-
ciples even greater and more vital. In this
world about us, at least as far as it is possible
for us to judge, there seem to be two great
classes of phenomena. One is the material,

by which I mean all that which is physical.
The other is the immaterial, by which I mean
all that which is psychological. To cite an
obvious example, if we slip and break our leg,
the resulting pain will be material, that is to
say, it will be caused by a purely physical pro-
cess the workings of which can be explained
on mechanistic principles. If, on the other
hand, we lose a friend by death, the pain we
suffer may be quite as acute or even worse,
but we are not able to explain why we feel it
on physical grounds; the psychological or the
immaterial enters. It matters not whether the
actual physiological processes set in motion
in the two cases be or be not analogous; the
ultimate cause in one case is physical, in the
other psychological. Similarly in the world
about us there are these two distinct groups of
phenomena. The art of the Middle Ages
occupied itself exclusively with the imma-
terial; Giotto turned from the immaterial to
the material. The difficulty of the modern
world is not that it has discovered the ma-
terial, but that it has so largely forgotten the
immaterial. Mind is incontestably greater
than matter. Any art which ignores this fact
falls into irretrievable error. From the time
of Giotto onward, artists have turned more
and more consistently from the more es-

sential to the less essential. The Middle Ages painted the soul; Michelangelo painted the body; modern art paints the clothes. This is the great and unanswerable indictment to which the art of Giotto must answer.

The only possible defence is an invasion. The charge, you say, is merely archæological, and archæology is of no account. As an archæologist I am prepared to admit it cheerfully. Archæology often is, and often has been, the enemy of art and its true appreciation; and it is only when strictly relegated to a subordinate position, that of scholar instead of teacher, that it can be of service. If I have emphasized this archæological indictment it is chiefly to demonstrate how completely wrong is the traditional — equally archæological — eulogy of Giotto first hallowed by Vasari, and since without end repeated, that Giotto is of interest, not so much intrinsically, as because he was the first to show the world the way from the dark shades of the mediæval night to the blinding brightness of the glorious new manner, as witnessed by the paintings of Vasari himself.

No, the merit of Giotto is distinctly not archæological. It is not as an historical curiosity nor as a shadowy figure from a remote and inaccessible past that he appeals to

us to-day; it is on the contrary because his work still lives, because in itself and on its own merits it still grips us with a power unsurpassed perhaps by that of any other master.

Much has been written but never half enough can be said of the repose of Giotto. Even across the redaubing of Bianchi, what a wonderful space surrounds his S. Croce frescos, and with what feelings of calmness, of refreshment we look upon this world of the artist's creation from which have vanished all the sordidness, the oppression of life. These paintings have the power of separating us from the noise and confusion of the century, from its restlessness, its world-weariness, as completely as the summit of some remote mountain. They call forth in our innermost being sensations of exaltation, of poise, of power. To know them gives the same inspiration as knowing one of those rare beings who have eliminated from life all that is unessential.

And this is precisely the secret of the feeling for space and repose in Giotto. He is preëminent among modern artists in knowing how to give the significant, and the significant alone. There is in his works but very rarely intrusion of unnecessary detail.

BEYOND ARCHITECTURE

I can cite no more striking instance of this virtue of Giotto than a painting, not by the master himself, but by his close follower Bernardo Daddi, which is now in the Jarves gallery at New Haven. The subject is the vision of St. Dominic. The legend relates that one day while the Saint was in Rome seeking to have his new order confirmed by the pope, he went into the church of St. Peter to pray; suddenly the two Princes of the Apostles appeared to him miraculously. and St. Peter placed in his hand a sword, St. Paul a book.

Let us stop for a moment to think what possibilities this subject would suggest to a modern painter or even to a painter of the high Renaissance. The imposing architecture of the church itself, the great arches, the vistas in perspective, offered a chance for the display of architectural accessories equal to that afforded by the "School of Athens." Then the artist might have introduced a stately procession robed in gorgeous colours, moving towards the altar in the background amid clouds of incense. And in the foreground, among the group of citizens present at the office, what a chance to introduce splendid portraits of well-known personages and the artist's friends.

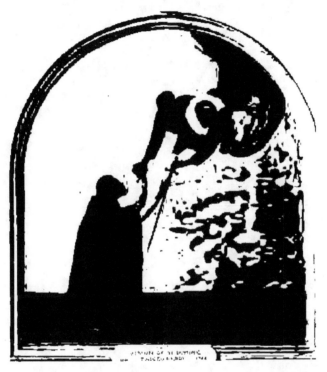

Bernardo Daddi, Vision of St. Dominic, New Haven

Of all these opportunities, however, Bernardo Daddi availed himself not at all. He introduced no architecture, no processions of priests, no citizens. The background in this painting is a simple wash of gold, divided by a horizontal line from a field of solid colour suggesting but not imitating the pavement of the church. Against this background the action is represented. Everything which is superfluous, everything which is unessential, has been eliminated. The fact of the miracle is set forth by itself with the utmost simplicity but in a manner which can never be forgotten by one who has seen it. Space, rhythm, composition, line, poetry — in achieving these elements the artist has discovered the essence of beauty, and in isolating them he has enabled us to realize them.

Why is it that this picture holds us with such power? Why is it that the sweep of line haunts our memory? After the artist has once taught us, we may find an infinite number of curves equally sweeping and beautiful in nature, which we would otherwise have been incapable of seeing or enjoying. The same with the other great qualities in this painting. Repose — is it possible that any picture should have a calm, a restfulness as great as that of nature? Space — can a little block of

wood, measuring at most some ten or twelve inches, possess the extent of the sea, or the loftiness of the sky? Why is it, then, that Bernardo Daddi makes us feel all these things so keenly, so overwhelmingly, so unforgettably?

The answer is, I believe, simply because the artist has learned the great principle of elimination. He has learned to do without. *Entbehren sollst, du sollst entbehren.* Of the manifold beauty in the world, from its puzzling confusing richness he has taken certain aspects, isolated them, separated them from everything which distracts, held them up to our attention so that we cannot fail to see them. Stimulated by his art, we return to nature and find we are able to enjoy these same beauties in the living world around us. After we have once grasped the isolated beauty, we are able to understand this beauty in connection with others, where at first the very exuberance of aspects, the very number of the opportunities for enjoyment, would have overwhelmed us.

And in the last analysis this is perhaps the mission of the artist, and by the artist I mean not only the painter, but the sculptor, the architect, the poet, the dramatist, whoever strives to create beautiful things. The artist, if he be a true artist, is a prophet, he is the interpreter of God to man.

THE ART OF GIOTTO

Is there one of us who had ever appreciated to its full the beauty of sunlight through the trees until he had seen the paintings of the Barbison school? Who had realized that there was a greater pleasure to be experienced in the mist and rain than in clear blue sky, before Whistler opened his eyes? After we have become acquainted with Japanese art, the snow must ever give us an increased thrill of pleasure. Could a person so unfortunate as not to have seen a Greek marble ever understand the poetry and beauty of manhood? Whoever comprehended the charm of femininity so well before he knew Correggio? Whoever grasped the tenderness and sweetness of mother-love without first knowing the Madonnas of Raphael? And so we might continue indefinitely. Each true artist has left the world the richer in sensations of beauty, of joy; each has revealed to those of us who choose to listen, new understanding, new possibilities of happiness. In the last analysis art is the key to nature and the world around us. This twentieth century of ours has produced countless histories natural and unnatural, animal fables strange as the bestiaries of the Middle Ages, above all classifications of birds, beasts and flowers. But if we are to understand nature in anything but

the most material sense, we must go far back
of the twentieth century. Not that I mean
the classifications are harmful; on the con-
trary, I firmly believe that all knowledge is
always useful. Let us know how to distin-
guish the Grey-checked from the Olive-
backed Thrush, the Yellow-bellied from the
Arcadian Fly-catcher; nay, let us even learn
Latin names, and when we see a robin speak
of *merula migratoria*. Only when we have
done this, let us not imagine that we have
understood nature.

The larger enjoyment of nature can only
come through the medium of the artist. It
is, I believe, a profound truth that to know
is to love — that is to say, if by to know we
mean the word in its broadest sense, in the
meaning of comprehension. If we all love
our friends better than other people, it is not
because they are necessarily more admirable
than thousands of persons with whom we are
unacquainted, but merely because we know
them better, because we have more under-
standing of them. Not that equal knowl-
edge implies equal love; that would obviously
be false, for there are always beings and
objects more admirable than others. I merely
mean that to appreciate the admirable, we
must first understand; and the greater our

understanding, the more we shall find to admire. We may even push the point further. There is, I believe, no one in the world whom we would not love, if we were able really to understand him, to enter completely into his life. Our dislikes are inevitably due to our own shortcoming, to our own failure to comprehend. The despairing wail of Shelley, "The wise lack love, and those who love lack wisdom," contains a fundamental error. If we look closely we shall find that the man who is truly wise cannot lack love, nor is it possible for him who loves to be wholly lacking in wisdom.

This same principle applies not only to man but to the entire universe of which man is merely an inseparable part. In measure as we know it, as we comprehend it, we find it admirable, we love it, we derive from it joy, happiness. In that most solemn of symphonies, the silence of the American forest, there break many motives of significance to him who understands. The recurrent song of the White-throat is, for example, capable of giving the same exquisite pleasure that we derive from the reiteration of the love motive in "Tristan." which it so unexpectedly resembles. In one case as in the other, however, we lose this pleasure of recollection unless our intel-

lect is sufficiently trained. The enjoyment of
nature is the most difficult, the most exacting
of occupations, but if it demands more from
us than anything else, it also gives more in
return.

This paper had been written, when my
attention was called to the fact that the theory
of art which I had believed to have been
followed instinctively rather than designedly
by artists, and never before to have been for-
mulated, had been put in very explicit words,
and that by Leonardo da Vinci. I quote from
Dr. Sirén's paraphrase, which is in part a
translation: " Leonardo's continually expand-
ing and deepening knowledge was, however,
to him its own reward and a constant source
of satisfaction. With its aid he was able to
penetrate deeper and deeper into Nature's
secrets and feel himself more and more com-
pletely their interpreter and master. Through
this knowledge he learned to know and love
Nature. ' Great love is born of great knowl-
edge of the objects loved. If you do not
possess knowledge of them you can love them
only a little or perhaps not at all. And if you
love them only for the good which you expect
to gain from them and not for the sum of their
qualities, you are like the dog who wags his
tail to anyone who gives him a bone.' . . .

"He [Leonardo] stood in a way above the ordinary antithesis of love and hatred — he loved because he knew and understood. Nothing was hateful to him, because he recognized that hatred meant only the lack of deeper knowledge, for ' love is the daughter of knowledge and love is deeper in measure as knowledge is more assured.' "

This confession by the artist who, although he lived in an age of decadence, nevertheless perhaps more nearly than any other realized the full possibilities of his calling, gives me greater confidence to state a view of art, of the truth of which I have been convinced for upwards of twelve years.

If, therefore, the artist be the interpreter of nature to man, at once the priest and prophet of God, it follows that his sin is especially damnable when as is unfortunately the tendency at the present time he prostitutes his art at the feet of Mammon. The true artist, like the true priest and the true prophet, must speak to all humanity, not merely to the aristocratic, least of all the moneyed, few. In fact I think it is no exaggeration to say that every art which is really great, really vital, has had its roots in the nation, the race, not in any class. Certain it is that in the case of Giotto this was preëminently true. His cycles of frescos at

Padova and S. Croce were painted for the people, and have for centuries increased the joy in life for whoever cared to seek in them inspiration. The Italians have a proverb, *essere non avere;* which may be translated, he who *is,* has. Beauty is always cheap; Heaven may be had for the asking. Happiness lies not in the material physical possession of works of art, but in the immaterial, psychological ability to appreciate the beauty which always surrounds us.

In conclusion, therefore, if I may presume to estimate the value of the art of Giotto, I shall place it exceedingly high, not because, as Vasari claims, he originated the modern manner, for he is not in reality responsible for this, nor would it be to his credit if he were, but because of the greatness of his prophecy. For perhaps no other artist has ever seen so keenly the beauty of the world, nor interpreted it so skilfully. From the study of the works of Giotto, as from those perhaps of no other artist, we turn to the world about us, stimulated in every nerve, with vastly heightened powers of enjoyment, more in tune with the mysterious, but ever-present, beauty of the universe.

PAPER ARCHITECTURE

IF to a certain extent it be true that clothes make the man, it is with a similar qualification true that technique makes art. In polite society a picture without technique appears to as great disadvantage as a person without clothes. An excessive recognition of this fact has led during the last half century to the use of the catchword "art for art's sake," which, as currently employed, means technique for technique's sake. In painting the value of the technical means has thus been grossly over-exaggerated. In architecture, on the other hand, it may well be doubted whether the value, or even the existence, of technique has been sufficiently recognized.

The modern technique of architecture differs fundamentally from that in vogue during the Middle Ages and in antiquity. In the Italian Renaissance there began a gradual evolution, or perhaps it would be better to say revolution, which has entirely altered the mechanical aspect of the art. If we seek for the fundamental cause of this radical change in means of expression, we shall find it in a

very obvious mechanical detail. It is the invention of paper, which has entirely changed the practice of architecture.

It may seem surprising that a mere mechanical and utilitarian invention such as that of paper should deeply transform, not only the surface finish, but even the inner spirit of a major art. Yet the event is not without analogy. Historians have long called attention to the influence which the invention of printing produced upon thought, though, of course, it is obvious that printing could not have had its effect had it not been for paper. Further improvements in the mechanical arts have produced an equally great transformation in the art of literature. Stenography and typewriting in recent years have vastly increased the quantity of the output, and have also with equal certainty altered the quality, though that for the better rather than for the worse, I should hardly venture to assert. Indeed, I am far from being satisfied that the influence of printing upon literature has been as beneficent as usually supposed. It has not been demonstrated that either Dante or Homer would have written more divinely had the printing presses stood yawning to issue their works in editions of the hundred thousand. An inspection of an American news-

stand has seldom failed to leave me with the
impression that the average of literary pro-
duction in the Middle Ages, in that hour
which we are accustomed to consider as most
dark, possessed greater merit, both from a
literary and an intellectual standpoint, than
the average of literary output to-day.

For the mediæval architect the only draw-
ing material available was, generally speak-
ing, parchment or vellum, which was com-
paratively expensive and used sparingly.
Architects and builders did indulge in its
use. Quite a few — all told, perhaps twenty
or thirty — architectural drawings of the
Middle Ages have come down to us. Villard
de Honnecourt, a thirteenth-century master-
builder, even possessed an entire sketch-book
filled with free-hand drawings. Recourse to
parchment, however, was had only very rarely,
and in general the builders appeared to have
worked directly in the stone. With the in-
troduction of paper, all this changed. Archi-
tects became able to sketch as much as they
desired. With very little expense and very
little effort ideas could be tried out on paper
and their effect judged. Moreover, paper
lay flat and could readily be stretched on
boards. It lent itself to mechanical drawing,
whereas sketches on parchment must, per-

force, be largely free-hand. The invention of paper was supplemented by the discovery of improved drawing instruments and a new convention of architectural drawing. The latter is the result of a long evolution. Du Cerceau, at the end of the sixteenth century in France, perfected a system of architectural perspective in which buildings were seen at bird's-eye view from above, so that the plan as well as the elevation was indicated. This method, delightful from a pictorial stand-point, was yet complicated and difficult, so that it was gradually supplanted by the modern conventional drawings which are entirely mechanical and, therefore, very quick.

It is evident that the new methods offered immense advantages to the architect. By means of drawings he was able to study and re-study, not only the building as a whole, but any of its details. He was enabled to judge with far greater accuracy what the ultimate effect would be, and he was able to foresee and solve many difficult problems of planning and intersection which otherwise might lead him into serious embarrassment. Indeed, so evident are the advantages of the modern method of construction, that it is very difficult for us to conceive how an elaborate building could have been erected

with only the simple appliances at the disposal of the mediæval builders.

As in the case of literature, however, the obvious mechanical advance does not seem to have produced the artistic results which might reasonably have been expected; it is easy to point out several particulars in which architecture created with the modern technique is inferior to that produced by the more laborious ancient process.

For one thing, there has resulted rigid mechanical exactness in the laying out of buildings. Nothing is easier than to draw straight lines with the help of a T-square and a ruling pen, and straight lines were adopted in drawings in place of the broken lines and curves which had been used in ancient edifices. From the drawings, the mechanical exactitude, the hard straight lines, were transferred to the buildings themselves, and thus were lost the vibrations that lent so much charm to mediæval and ancient architecture.

In our modern cities, the fronts of the buildings are elaborately finished and often coated with cut stone or other forms of decoration. The sides and back, however, are generally left unfinished, and are apt to be exceedingly ugly in their crude lack of ornament. It is doubtless the theory that the back and sides

will not be seen, but as a matter of fact they constantly are visible. This so too familiar defect of modern architecture I believe to be due to the use of paper. Modern architectural drawings are made in elevation, that is to say, from an imaginary and artificial point of view from which only one face of the building is seen. In actuality, of course, a building is never seen under precisely these conditions. The fact that buildings are studied in elevation and not in perspective leads to many blemishes, of which the unfinished backs and sides are the most conspicuous, though perhaps not the most insidious.

The use of paper has also led to deterioration in the quality of detail. In mediæval times the man who cut a capital was himself an artist. He designed what he executed. The discovery of paper has made it possible for the architect or his office force to design on paper all the details. The drawings are given to the workmen, who copy them mechanically. The result has been a great decline in craftsmanship. This has been accentuated by the unhappy fact that the ease of the new method has greatly stimulated production. Modern architecture, like everything else modern, has too often been whole-

sale. It was so easy to draw capitals that the architects themselves ceased to bother with them, and even the office force became annoyed at the task. The thoughtless drawings came to be executed more and more thoughtlessly by labourers who felt no joy in what they did. The trades-unions gave the *coup de grâce* to the art of stone carving. Mediæval guilds differed from modern trades-unions fundamentally in that the guild was organized primarily to safeguard the art, to ensure the thorough training of all who professed it, and to maintain the highest standard of quality in the production; while the modern trades-union seeks only to safeguard the material welfare of its members. The trades-union has no interest in maintaining quality. For its selfish ends it even seeks a lower standard of production.

Trades-unions have been able to exert this baneful influence upon architecture, only because of the evolution which has taken place in the art. It is a mistake to conceive of the trades-union as occupying to-day the place held by the guild in mediæval times. The modern system tries to compensate for the inferiority of present-day labourers by producing a class of specially trained architects to direct them. The decadence of

[157]

modern labour is evident if we stop to think
of the dire results which almost inevitably
follow the attempt to erect a modern building
of any pretensions without an architect. Yet
nine-tenths of the architectural masterpieces
of the world have been erected without an
architect, in the modern meaning of the term.
Throughout the Middle Ages such a func-
tionary was unknown. The so-called archi-
tects of the Italian Renaissance were almost
without exception trained as apprentices to
painters or sculptors, and were much more
analogous to the mediæval master-builder
than the modern architect. Of the three best
known English architects, Inigo Jones, Sir
Christopher Wren, and Lord Burlington, not
one was a trained architect. In America we
possessed no architect before Charles Bul-
finch, a name which marks the close of the
great period in American architecture. The
professional architect was really a creation of
the French, and more precisely of Colbert.
It is only during the nineteenth century that
his right to existence came to be generally
recognized. The rise of the architect was
due to an attempt, in a large measure success-
ful, to counteract the decline in the quality of
labour.

One of the most serious, though the least

tangible, evils of paper architecture is the
fact that the architect no longer senses the
building growing beneath his hand. It is
undoubtedly a great advantage for the crea-
tive artist to work directly in the stone.
There comes a feeling from the material
itself, a subtle unity with the medium, which
cannot be attained when the artist does not
himself execute. Moreover, the very labour
of the execution compels a closeness of study,
forces a thoughtfulness which is lacking when
the conception is translated from paper.
This fact has been so thoroughly demon-
strated in sculpture that, as a rule, sculptors
who possess artistic conscience (there are still
a few who have not become commercialized),
will not allow their works to be executed by
another hand. Paper architecture is always
executed by another hand. Thus it loses.

Another quality which paper architecture
has lost is the element of colour. Until the
introduction of paper, colour played an al-
most predominating rôle in architectural
effects. When buildings began to be studied
in drawings instead of in actuality, colour,
which does not appear in a drawing, came to
be eliminated. Instead, there was developed
the new art of rendering. This often supplies
in the drawing the important element of

polychromy, so potential in artistic effects, but the colour is not reproduced in the actual building.

In recent years the introduction of photography has had a profound influence upon architectural art. Even before, engravings and other methods of reproduction had led to the use of foreign and distant models, for the architect in search of inspiration found it more convenient to turn to books than to the actual monument. It therefore became as easy and natural to copy a Burmese pagoda or a California mission as a Colonial house. The natural consequence was that eclecticism, that use of models of all types and styles, which is, perhaps, the dominating, but by no means the most fortunate, characteristic of present-day architecture. Moreover, photographic effects have been very largely sought in design. I am amazed to see in turning over the pages of current architectural magazines, how much more effective photographs of modern buildings are than the structures themselves. It is undoubtedly because the design was itself inspired by photographs. The architect has selected those effects which appear best, not in the actual building, but in reproduction, and these he has copied or enlarged upon.

Indeed, it is from reproductions in books that fashions in architecture are set and reputations made. The rôle played in the history of English architecture by Campbell's "Vitruvius Britannicus," is well known. Yet this work was composed with no higher motive than that of self-advertisement in which the author so admirably succeeded. It may well be doubted whether the Adam Brothers would enjoy half the reputation they actually possess, had they not advertised themselves by a book useful to architects. There is hardly a modern architect who does not know and admire the finely pictorial works of Mr. Charles Platt, yet it has been my experience that those who are most influenced by them have seldom seen them in the beautiful originals, but are acquainted only with the reproductions in Mr. Platt's book.

All told, it appears that evolution in architecture has not been in the direction of unqualified advance. The obvious advantages gained have been counterbalanced by serious losses. A realization of this fact has produced in recent years a considerable dissatisfaction with the state of things as they are, and more than one attempt has been made to overthrow our existing system. It has been believed that at all costs ancient conditions must be revived. [161]

A little thought, however, will, I think, be sufficient to show that this can never be done on a large scale. We cannot go back to the Middle Ages. The ancient guilds are dead. The architect has come to stay, and there is no possibility, even were it desirable, that he should be replaced by a master-builder. Craftsmanship and the conditions of labour we may not too unreasonably (if we be of optimistic temperament) hope to improve; but the fundamental technique of the art cannot be rolled backward. We must produce paper architecture as we produce paper books. It would be as unthinkable to revert to mediæval methods of building design as it would be unthinkable to issue a great poem in manuscript on parchment.

Moreover, after all, in the last analysis, the faults of modern architecture are not so essentially those of the technique. The disadvantages of paper architecture might, for example, be overcome by the use of tri-dimensional models, employed with such effect at Bryn Athyn. Certain it is that new methods should be devised to meet new conditions, and if the new conditions have produced difficulties that have not been solved, the fault lies not so much with the conditions themselves as with us who have failed to meet

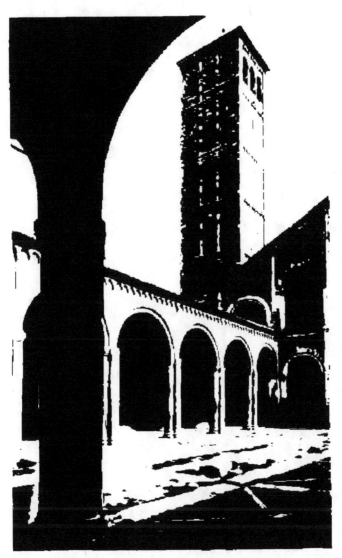

Atrium of S. Ambrogio at Milan

them. It is distinctly the public, not the architects, who are to blame. Many modern architects are conscientious artists, but they are too often helpless in the hands of the spirit of the time. America of the nineteenth century was not a land sympathetic to art. Artists were born, but we gave those of them that were true artists no encouragement. We produced one great novelist, Henry James. He expatriated himself. We produced one great painter, Whistler. He also expatriated himself. We produced one great musician, MacDowell. He was harassed to insanity, and among his chief persecutors was an institution which passes as a centre of culture. James, Whistler and MacDowell, although unsympathetic with the American environment, still produced work of high calibre. Less strong men, however, were doubtless sucked into the mediocrity which surrounded them by the Great Boyg, that most uncompromising spirit of compromise. But if some painters, musicians and poets have produced in America great art in spite of their environment, an architect can hardly hope to do so. The chance of the architect depends upon immediate recognition. He cannot wait for vindication by time. If he is not given his chance, he can leave nothing for posterity to judge. [163]

Also in a more subtle way the architect is the child of his age. He must build in the manner in which men about him build. No individual, however great a genius, could have produced the cathedral of Reims in the fifteenth century at Florence. The modern architect must build in the modern manner. He must, moreover, contend with modern conditions, and these conditions have been very adverse to the perfection of his art.

No influence has been more pernicious than that of machinery. Nothing has played such havoc with the æsthetic sense of the race, or with craftsmanship. We are all familiar with what machinery did to furniture. We are also familiar with the gingerbread carved woodwork introduced by its gentle ministrations into the Victorian House. We do not, perhaps, often stop to consider the deadening effect upon the æsthetic sense of the people produced not only by the habitual contemplation of such abortions of art, but by long days passed in the presence of machinery and far removed from everything beautiful. The machine also supplemented the T-square in producing that rigid regularity which is the curse of modern buildings.

In addition to the machine, architecture has had to contend with other enemies no less

dangerous, more insidious. A people intensely interested in the latest inventions in plumbing, steam-heating and electricity, but indifferent to the expression of the beautiful, has pushed the artist downward on the primrose path. He who sold his birthright was rewarded with flesh-pots fatter and greasier perhaps than any ever before offered; he who was obdurate was crushed. The power of vicious folkways, the tyranny of the majority has been victoriously asserted. Architecture has been engulfed by the commercialism of the age; and in so far as it has become a business, it has ceased to be an art.

In such conditions it would be most dangerous, even were it practicable, to revert to the mediæval system. The architect is at present the only safeguard for art against the degeneracy of craftsmanship and the ignorance and vulgarity of the people. Hope for the future lies, not in stopping the education of the architects, but in beginning the education of the general. When our public possesses something of the appreciation of beauty felt by the people of Greece in the fifth century B. C., by the people of France in the thirteenth century A. D., or by the people of Italy in the fifteenth century, then we shall produce great art. The seeds of genius are sown

[165]

among us, as thick, perhaps, as they ever have been; but unless they fall on soil that has been worked and fertilized, they can never reach their full fruition; they must continue to be choked by weeds, starved between rocks and unbroken clods, perverted by the irresistible force of environment.

ART AND THE GENERAL

HOMERIC laughter I fancy ripples through the halls of Olympos whenever a mortal — be he philosopher or the latest military critic — presumes to prognosticate the future. Nevertheless, I dare to prophesy that when the art of the end of the nineteenth century comes to be studied as an historical epoch of the past, it will appear that its character is at present undergoing a gradual, but none the less radical, transformation, of which we, because of too great familiarity, are hardly conscious. The change which began some time ago and promises to continue in the future, is not superficial, affecting merely the externals of art, as post-impressionism, cubism and futurism have affected painting, ruffling the surface and distracting attention for a moment without stemming the force of the current beneath. It is, on the contrary, an alteration in the very nature of art, an artificial dam unexpectedly flung across the downward flowing stream. So slowly has the retaining wall been built, that its usefulness, even its necessity, has

hardly been questioned. The few petulant voices that in recent years have been raised in denunciation are already forgotten. And for once the judgment of the majority has been right — clearly, indubitably right. It is better, far better, to go backwards than downwards. The dam is necessary, vital for the salvation of art; for it is the only possible means of preventing the trickling stream from drying up. It is therefore well that work upon the masonry has proceeded.

The only serious divergence of opinion has been as to how high the cross-wall should be raised. Some, building consciously or unconsciously upon the postulate that " the history of art is the history of a decline which begins with Duccio," have tried to place their *petite sensation* at the level of the pre-Giotteschi sources; others have tried to back up the stream as far as the Quattrocento, the Cinquecento, the French Renaissance. But it is only a question of degree. On the fundamental issue of backing up there is universal agreement. And in the placid and serene, if also slightly stagnant, waters of academicism our artists swim about, revelling in the nude, or plume themselves upon the banks in the sunshine of a romantic landscape.

The dam is the systematic training of artists.

As the force of the waters has gathered, it has been found necessary to reinforce this first with a second wall, systematic training of the public to appreciate. Work, especially upon this newer part, is far from completed; indeed, has only been well begun. Nevertheless it has already produced a perceptible effect upon the art of our time, quite enough to supply data for an estimate of the probable result when, and if, the wall be carried higher. The question is one of no light moment. We are dealing with a matter basic and fundamental, liable to affect radically the sensibilities, indeed the happiness, of our children and our children's children. It is therefore not merely a matter of academic interest to inquire whether or not there be hope that, by means of training the public to enjoy, art may be turned from its perverse channel into the unobstructed and natural course from which, unhappily, it was long ago diverted.

The newer part of the dam may best be studied in connection with the older portion, to which it is closely related. That artists should be trained, fortunately no longer requires demonstration. Technical schools are no experiment. They have been tried and tested, their utility proved. It must

not be forgotten that the systematic train-
ing of artists is a modern idea. In the good
old days, painters, sculptors and architects
served a period of apprenticeship under
masters, after which they became themselves
masters. There were no regular courses, no ex-
aminations, no degrees. Their education was
hand-made, variable, not standardized. In
modern times, the curriculum and prescribed
course of study have supplanted the old
method. This is to some extent true in all the
arts, but has been carried to the greatest ex-
treme in architecture. The trained—I almost
said machine-made — architect, armed with
his diploma and carefully planned education,
is a product of the modern age. His beginnings
cannot be traced further back than the seven-
teenth century in France, and only about the
middle of the nineteenth century did his right
to existence come to be generally recognized.
The utility of the school for training the
architect has now, however, been acknowl-
edged as a necessity both by the profession
and by the public.

The fact remains that our present-day art
created by men with special training is in
many respects by no means superior to the art
of bygone ages created by men who enjoyed
no such advantages. The statement may not

pass unchallenged, but is, I believe, true. In fact, one finds it tacitly admitted on all sides. Mr. Cram contributed to a recent number of the "Atlantic" an article of extraordinary significance. This illuminating piece of criticism proves a fact of which the author himself was probably unconscious — that the creative artist of to-day is mistrustful of contemporary art. Despite the restraint necessarily imposed when speaking of other artists who are doubtless also his personal friends, it is only too evident that Mr. Cram looks upon the general course of American architecture with something very like despair in his heart, relieved only by a forced optimism for the future. We have, therefore, admittedly one of the greatest of our living artists feeling that his times are sadly out of joint, looking upon the great mass of work by his contemporaries as stale, flat and unprofitable. Nor is this attitude confined to Mr. Cram. Few practising architects would seriously maintain that their modern constructions rival the ancient masterpieces they attempt to reproduce. The new movements in painting originated because of well grounded dissatisfaction with current pictorial standards. The reactionary magazine, "The Art World," has been the most powerful agency in America for

gaining converts to the extreme forms of futurism.

Never before have artists been so openly dissatisfied with the tendencies of their own time. We can hardly imagine Leonardo denouncing the art of the Cinquecento, Villard de Honnecourt exalting the Romanesque at the expense of the Gothic, nor Bernini scolding at the Barocco. One age has frequently pointed the finger of scorn — usually quite without justification — at earlier periods. Vasari never wearied of patronizing the Tre- and even the Quattrocento, but to him his own age was always sacred, whatever it may seem to us. The Renaissance centuries derided the mediæval, but never doubted that they themselves had rediscovered the true secrets of classic beauty. In fact, I fancy the instinct is deeply rooted in every man to consider all things good or bad, estimable or despicable, in measure as they resemble or fail to resemble himself. That modern artists should actually show symptoms of being dissatisfied with their own art, gives grave reason to fear that it has indeed fallen into a parlous state.

It is not difficult to see that, in fact, the evolution of the trained artist has but barely counterbalanced a tendency towards degen-

eration inherent in the nineteenth century. It is particularly evident in the case of architecture that the art would have undergone a precipitate and alarming decline, had it not been, by a happy chance, that the appearance of the trained architect in some measure compensated for the falling off in general taste which took place in that unhappy time. Scientists have, I am told, pointed out that in the doctrines of evolution and of the survival of the fittest, there is no explanation to be found why appreciation of the beautiful should continue to exist in the race. The æsthetic sense cannot be accounted for by the material needs of the struggle for existence. That during the materialistic nineteenth century this god-given quality was not evolved out of existence, that something was saved of the artistic sense with which humanity was once endowed, was due to the schools of art. In architecture, immediately technical schools were created, although it was the darkest hour of the Victorian age, conditions improved. Effect never followed cause more swiftly, more unmistakably. The same thing happened, somewhat less obviously, in the other arts.

We too seldom, I think, stop to consider the strength of the forces arrayed against art in

our modern America. The wonder is, not that feeling for the beautiful has languished, but that it survives at all. There is a crushing strength in the tyranny of the majority, a force which withers and kills him who will not conform to current standards. We have witnessed in recent years the slang catch-word " high-brow " do incalculable harm to the cause of sweetness and light, turn from their convictions, by fear of ridicule, even those who should have fought in the front ranks against the powers of darkness. For me, Washington is the most deeply tragic spot in America. This city of magnificent vulgarity is the cemetery of genius. Buildings, sculptures and paintings bear witness to the battle which has been waged between ideals on the one side and commercialism, materialism, opportunism on the other; and how many, how pathetically many, show art crushed by the weight of flesh-pots; how many show the man of fine perceptions vanquished by the tobacco-spitting politician; how many bear branded on their face a dreadful record of the Great Refusal! The word " Copy-right " placarded on the mural decorations of the Congressional Library is the epitaph of American art. It is strangely refreshing to escape to the pre-commercial atmosphere

of Mount Vernon after having breathed the suffocating air of the capital. Yet the sad fact must be faced that the city of Washington is typical of our country and of our age. The campaign against refinement, against intellectuality, against beauty, which has there been waged, has been carried on throughout the land. This is the spirit with which art has had to contend.

It must also, I think, be recognized that the cosmopolitanism so characteristic of the modern age is curiously fatal to art. It almost inevitably deprives the artist of that leisure, of that opportunity for introspection and thought, of that seclusion from practical affairs which most temperaments imperatively need in order to achieve their fullest intellectual development. *Nulle nature ne peut produire son fruit sans extrème travail, voire douleur.* The bitter epigram of Palissy is not without its grain of eternal truth. Cosmopolitanism which always tends to force the artist into the excitement of social intercourse and of active affairs, may make his life more pleasant, but inevitably distracts his energies from what should be not only the supreme, but the single purpose. Henry James's "The Lesson of the Master" is vastly significant, because written by a man

[175]

who knew thoroughly both the great world and artistic creativeness.

Art has, indeed, generally flourished best in provincial cities. In the time of the Renaissance, Rome, the cosmopolitan city of Italy, exerted a very unhappy influence upon artists. She called to herself the greatest that the smaller towns produced, but she gave birth to almost none. It is precisely this that our cosmopolitan American cities have done, especially in the case of musicians. With the hope of gain, we entice to ourselves from all over the world the most celebrated virtuosi, but we ourselves produce very few. Moreover, Rome seldom failed to exert a baneful influence upon the artists who came to her. Michel Angelo produced the Sistine ceiling when he was fresh from Florence, but as he lived in Rome his powers steadily declined. Raphael's art deteriorated so rapidly in the capital, that it is happy indeed for his reputation he was cut off by an early death. Neither Signorelli nor Ghirlandaio nor Botticelli nor even Bartolommeo della Gatta was able to give of his best in the Roman environment. It seems that our American cosmopolitanism exercises something of the same withering power.

The forces drawn up against art in the

nineteenth century were therefore no mean
ones. Had her existence depended, as in the
past, upon untrained individuals, she must
necessarily have succumbed. It was the
trained artist who kept the divine spark afire,
it is in the conscience of the trained artist
that hope for the future lies. But that his
victory may be complete he needs reinforce-
ment; he needs the help of a public trained
to appreciate the best in art.

In olden times the race got along very well
without instruction in the appreciation of
art. Ancient Greece was not absolutely with-
out its critics, but it is hardly open to doubt
that the Athenians studied their masterpieces
with much less assiduity than we of to-day
bring to the same works. Yet their instinctive
enjoyment was more valuable than our con-
scious and somewhat laboured appreciation.
The people of the thirteenth century in France
must have brought to the Gothic cathedral,
without any instruction, a feeling for its
beauty and an intelligent comprehension of
its content which a two-hour course would be
quite inadequate to give even the most intel-
ligent modern collegian. The appreciation
of art, which was a natural heritage in the
past, the present generation can acquire only
by conscious effort.

The same thing has happened with literature. The English of the time of Elizabeth doubtless enjoyed and to a certain extent appreciated Shakespeare's plays without being taught them. To-day in our schools and colleges we find it necessary to teach Shakespeare. If we did not, the great majority of our students would never rise to sufficient intellectual heights to appreciate the plays, and the literary culture of the race would thereby be impaired. It is equally necessary that the public should be instructed in art, or it will no longer be able to enjoy the great masterpieces which were formerly enjoyed without instruction.

Moreover, it is evident that the character of an art depends primarily and fundamentally upon the character of the people who produce that art. No genius, however exalted, could have built the cathedral of Reims in the Florence of the fifteenth century. Had Michel Angelo lived in the age of Giotto he would undoubtedly have painted great things, but not the works he did actually create. No man can avoid the spirit of his time. It is necessarily the environment which creates art. To educate artists therefore is not sufficient. It is even more vital to create sympathetic and stimulating surroundings for the

artist. Failure to perceive this fact, it cannot be too solemnly emphasized, is the fundamental fault with existing conditions in America.

The influence of environment upon the artist is exerted in two ways. The first is by the economic law of supply and demand. The artist must place his wares. More than that, he must be stimulated by demand and appreciation to produce the best of which he is capable. He must have an audience able to understand. The super-artist can never be until there is created a super-public to comprehend.

The public also affects that artist in a more subtle, intangible manner. In art, as in all things else, heredity and environment exert a vital influence upon character. In the Middle Ages and the Renaissance son generally succeeded father in the calling of artist, and thus might both inherit and absorb from his environment the influence so necessary for his development. With us, the future artist has too often already been coarsened by adverse heredity and adverse environment before his professional training begins. We can hardly return to the mediæval system of guilds and apprenticeship, but by educating the public we may enormously improve both the heredity and environment of our artists to come.

BEYOND ARCHITECTURE

If the desirability of raising the taste of the general be, then, granted, some doubt may not unreasonably be entertained as to how, and whether, this end can be attained. Any idea of a single and universal panacea must be at once discarded. The submarine cannot be worsted in a day nor by one weapon.

Courses on art in schools and colleges form the most obvious and doubtless also the most effective method of attack. It must never be forgotten, however, that such courses have their distinct limitations. If the history of art were a required study in every school and every college of the country, as I should like to see it, if it were made a subject of equal importance with spelling, reading and arithmetic, the battle would still not be entirely won. We should have to be on our guard lest the study of art should become too academic, should lose its freshness, that art should in fact become a sort of dead language, such as teaching of the wrong sort has made of that most living of tongues, the Greek. It is not enough that the people should know art, they must love art, they must absorb art. It must enter into their daily lives as vitally as the language which they speak.

Moreover there has been, I admit it, a great tendency in America to overestimate the

value of instruction. Courses have become a sort of fetish; people who ought to have been doing have been studying, and when they have finished studying they have been found incapable of doing. He who really tries, as a general thing, does. The value of experience as a teacher can hardly be overestimated, and it may be doubted whether the pupil does not as a rule learn more by an actual attempt than by any quantity of theory.

When all is said and done, however, we must acknowledge it is vitally important that art should be taught in schools and colleges. The same arguments are equally cogent against the teaching of any subject — history, geography, grammar — as against the teaching of art. Yet it would be manifestly absurd to abolish all schooling. That we are obliged to acquire the ability to read by being taught, does not prevent that ability from being highly useful and even pleasurable. When the race learns the alphabet of art as an essential part of its education along with the alphabet of letters, when the existence of art is called to the attention of our youth (instead of being concealed from them as is too often the case at present), it is almost certain that there will result a radical change in the attitude of the public.

BEYOND ARCHITECTURE

The work of education in art has already been taken up in scholastic institutions. Fashionable girls' schools have for some time been teaching the history of art, probably not more incompetently than other subjects. In the public schools, where standards are higher, much still remains to be done, but the entering wedge has been driven. Finally, at our universities the study of art has at last been put nearly on a plane with that of machinery, journalism and law. The first department of art in an American college was established at Harvard by Charles Eliot Norton nearly a half century ago; one by one the other great universities and even the fresh-water colleges have followed this example. The importance of such educative work is exceedingly great. The college-men are on the whole, perhaps, the most influential class in the country. If they can be reached, and reached vitally, in their formative years, there is good hope that the back of Philistinism may be broken. It is, therefore, of the deepest importance that the system of instruction in art already initiated in our colleges be extended and developed to the utmost. It is lamentable that at present the great majority even of college graduates goes out into the world completely ignorant of art. In the seventeen and more

years devoted to the education of our children, too often not a single moment is found for the subject which is capable of adding more than any other to their happiness. This neglect is especially to be deplored in America, where artistic influences can less readily than elsewhere be absorbed from environment. Even the minority of students reached is (barring a few exceptionally enlightened institutions like Harvard) allowed to elect art only in junior and senior years, that is to say, too late. Thus do we deprive our youth of the heritage of joy that is their inalienable right. We send them out into the world æsthetically castrated. It is absurd to restrict knowledge of art, as it would be knowledge of reading, to the few who capriciously may choose to take up the subject in the last years of their education. Courses in art must be brought down from junior into sophomore year; from sophomore into freshman year; from the colleges into the preparatory and high schools; from the high schools into the elementary schools; and from the elementary schools into the kindergartens. Indeed, the appreciation of art, like spoken languages, can often be acquired only, and always be acquired best, if the foundations are laid in infancy. Foreign tongues and the more thoughtful study of

art are subjects that might to advantage be substituted for the vapid sentimentality that absorbs so large a place in the system of Froebel.

A second method of affecting the public is through criticism. There is, unfortunately, considerable disposition to look askance at this most useful weapon, even on the part of those who should most benefit by its use.

Mr. Cram, in the article to which I have already referred, has cleared up the reasons for this. He has pointed out that the present-day artists, or at least those of them who possess great reputation, wield an almost unprecedented authority over their clients. The artists are able to force upon the public their own standards of what is good and what is not good, to bully their clients into accepting what pleases them, the artists. This state of affairs is in some ways hopeful, in some ways discouraging. It is hopeful in so far as the artists are probably better judges of their own work than are clients. It is discouraging in that the docility of the public argues an ignorance upon which the charlatan is often able to impose. Besides, it is obvious that a man who really loves art must have his own taste.

Not content with wielding this despotic and unprecedented power over their clients,

modern artists have even reached farther and frequently claimed the right to exemption from criticism except by one of their own number. They maintain that no one who is not an artist can possibly understand the work of an artist. There has thus arisen a sort of freemasonry of artistic appreciation. The initiated hold zealously the secrets, to which no profane person may be admitted. Art is not for the public, but for the artist. The layman is to enjoy that which the artists tell him is right. Great scorn is heaped upon any adventurous spirit who dares lift his head, not being of the inner circle.

The position would scarcely be worth serious discussion, were it not that by force of banality it has acquired a sort of authority. If we except Vasari, Berenson has certainly done more to clarify our ideas of Italian art than all the painter-critics put together. So far as I know, Ruskin never erected a building; yet notwithstanding obvious deficiencies, I suppose him to have been the greatest architectural critic who has lived. If the reader takes exception to the statement, let him try to name another book which has exerted as great, and on the whole as beneficent, an influence as the " Seven Lamps." But very few of the scholars and critics of Homer

have been poets. Yet I never heard anyone claim that they were for this reason disqualified as interpreters. Indeed, it may fairly be doubted whether the creative artist be not by that very fact at a certain disadvantage as a critic. If he be a real artist, if he be sincere, he must believe intensely in his own vision, in his own manner of doing things. This many times precludes sympathy with, and understanding of, another vision, another method, which, nevertheless, may be capable of yielding equal delight to the public. The critic who is not an artist may frequently possess greater breadth of view. To cite obvious examples, I have seen few creative painters who comprehended the primitive painting of Italy, and still fewer creative architects (Mr. Cram is a notable exception) who understood Gothic architecture. These archaic arts must almost necessarily remain sealed to a person creating in the present styles. It may be granted that the critic occupies an office lower than that of the artist. Bernard Shaw's epigram might be amended to read "he who can, does; he who can't, criticizes." None the less, he who can't may peradventure criticize better than the man who can. The professional critic is apt to possess greater competence than the

artist who takes up criticism in an amateur capacity.

The present education of the public by artists is a proven failure. The great majority of men never comes in contact with artists at all, and for those that do, habits of bad taste have already become too inveterate for real education to be possible. The proverbial tired business man may feel his own insufficiency, may submit to being bullied 'and cowed by his architect or sculptor, but he can rarely give the latter that intuitive sympathy which is essential. We can only teach our people to love art by reaching them before they are too old to learn.

At present, our criticism of contemporary art is deplorably weak. Indeed, as far as regards architecture, it is practically nonexistent. Neither our public nor our architects have the advantage of seeing buildings through others' eyes. The trade journals are discreetly laudatory of all they publish. The lay newspapers and magazines avoid all mention of architectural art, as carefully as a cat avoids wet feet. A vital and important method of education is thus lost. There can be little doubt that the criticisms in our newspapers have played an important, and on the whole very beneficial, rôle in forming popular

taste in music. The same result might readily
be attained in the other arts. Exhibitions of
painting and sculpture do, it is true, receive
considerable notice, but our public monu-
ments are usually passed by in silence. We
owe to Mr. Barnard's "Lincoln" a deep
debt of gratitude for having roused the public
for once from its habitual apathy into heated
discussion. One clever cartoonist caricatured
the supercilious lions of the New York Public
Library with the lorgnettes they so clearly
lack; but it is unfortunately rare for humorists
to seek inspiration in art which might be for
them so fertile a field. The educational value
of such witticism is incalculable, for it has the
power of impressing the lay mind more than
columns of prose. In its absence our public
is too often lethargic. The pediment statues
of the same library would still have been
meekly accepted, had not the indignant
sculptor disclosed their real value in a law-
suit. America could not be so gullible if
there were criticism. Not a protest is raised
when our cities are disfigured by inexcusable
monuments, like that not so long ago erected
to Verdi in Sherman Square, New York, or
the Soldiers' and Sailors' Memorial in New
Haven (I almost wrote the Soldiers' and
Sailors' Memorial in any city). Where large

prices tempt to politics and corruption, with us the intriguer is too apt to succeed in crowding out the genuine artist. Were there free and general discussion, it would hardly be possible for Boston to ruin her State House by sacrilegious additions in which the real marble and poor architecture contrast so strangely with the poor materials and real architecture of the original building; or to place a subway kiosk on axis with the false entrance in the north elevation of the Public Library, so that this entire monumental composition leads up impressively to a hole in the ground. A few writers of wit might soon succeed in casting into discredit some of the most glaring faults in our contemporary architecture and decoration. Thus the pen of the critic, which is denounced only by those who find profit in the ignorance of the public, should be of inestimable value to the cause of art.

Criticism has even greater possibilities for service in interpreting the meaning of the artist, and awakening interest in his more subtle productions. It may exert a most beneficial power in leading the public away from the meretricious by making comprehensible that which is of finer grain. The poetic and deeply illustrative statue of Nathan Hale on

the Yale campus is highly esteemed by a small circle particularly interested in art; but the great majority of an exceptionally enlightened community is probably still unaware that this is a work of extraordinary merit. Miss Hyatt's " Jeanne d'Arc " triumphs gloriously even over her Victorian Gothic pedestal, but her victory is unacclaimed. The days when the Sienese populace carried the Duccio " Maiestà " in procession through the streets are evidently long past. The church at Bryn Athyn is an epoch-making masterwork of architectural art, created with joy, full of artistic conscience. Less important certainly, but to my way of thinking almost as far in advance of its age, is the quadrangle built for Mr. Miller in New Haven and recently acquired by Yale. These two together raise our national architecture to a new level of intellectual and artistic attainment. Yet the New Haven structure, and even the Bryn Athyn church, if not entirely unknown, are certainly far less spoken of than many quite commonplace buildings. If we had adequate criticism, the value of such works would be at once recognized, and encouragement thereby given for the production of others inspired by equally high ideals.

In addition to formal teaching and criti-

cism, the cause of popular education in art may be advanced by the influence of museums. Such institutions, indeed, offer the most direct method of calling to the attention of the public the best in art. Nothing in America is to me more inspiring, nor fills me with such great optimism for the future, as the rapid development of our museums in recent years. Two decades ago the Metropolitan in New York, as an artistic force, was negligible. To-day, both by the intrinsic merit of the objects it possesses and the hold it has obtained upon the people, it is the greatest single power making for artistic culture in our land. The Boston Museum in only less important. Many similar institutions in other cities — Chicago, Worcester, Cambridge, New Haven, Brooklyn, Minneapolis, Cleveland — are carrying forward on a more modest scale the same admirable work. Mistakes have inevitably been made. The collections are weak in many directions where they might and should be strong. Nervous prosperity frequently appears in the accumulation of great numbers of objects of minor importance. Even more discouraging is the tendency to divert funds from the purchase of works of real art to the construction of showy and unnecessary buildings. All told, nevertheless, the advance

of our museums has been thrilling, and is full of good omen for the future.

An educative influence may also be exerted through books on art considered from an archæological or historical standpoint. Such literature supplements formal teaching, but has a more restricted scope. It presupposes an intellectual training seldom found in the general public or even among creative artists. Those unable to understand archæology are apt to think it dry and uninteresting, little perceiving it is the most intensely alive of modern sciences. It is distinctly gratifying that there is now a much wider public reading books on the history of art, even those of real merit, than formerly. This can only mean that the highly intellectual pursuit of archæology is making progress. It would be Utopian to imagine it could ever appeal to the crowd. The wider the circle of intellectuals interested in such a subject, however, the greater will be the influence it exerts. Ideas will filter through in time, although often in perverted form, to the general public. The influence of archæology upon creative art in the past has been very powerful. Great movements like the Greek and Gothic Revivals must be laid to its credit or discredit. At the present time architects are adopting

construction in lines which are not straight in consequence of the archæological discovery made nearly a half a century ago by Mr. Goodyear that mediæval buildings were so erected. The influence of archæology upon architecture cannot now, even were it desirable, be eliminated. It is, therefore, well that this influence should be exerted as finely and thoughtfully as possible. Happily not only is the quantity of our American archæology increasing, but its quality is being raised. The extent of this improvement may be illustrated by the fact that a very few years ago a director of the Metropolitan Museum in New York, for reasons apparently of pure caprice, consistently falsified the provenance of his archæological finds. The same director, for convenience in shipping, habitually cut off the heads of ancient statues, throwing the torsi away. Such things would to-day obviously be unthinkable. The progress scored in the science of archæology cannot fail in the long run to exert a favourable influence upon art.

Much effort has been expended in attempts to instruct the public in art by means of illustrated lectures. It is my impression that the educative value of this particular form of amusement, like that of moving pictures, has

been exaggerated. The prejudice of the Anglo-Saxon against pedantry has wrought irreparable harm to our scholarship and our intellectual life, and I fancy we have here a by-product of its pernicious workings. Lecturers, through striving to be unintellectual, have become merely dull. However this may be, the fact remains that lectures, as a rule, do not appeal to the intellectually alert. The audiences are apt to be exceedingly poor in spirit. This is the more unfortunate, because it is extremely difficult even for a person trained to close application to retain without notes for any length of time a clear impression of an hour's talk. On the other hand, lectures at least do no harm, and reach many people whom it would be impossible otherwise to touch. Any crumbs of information or enthusiasm the lecture-going public may pick up, must be considered pure and unexpected gain. A vitalizing of the technique of lecturing and the maintenance of a higher standard in the personnel of the lecturers might make the weapon more effective.

The education of the public should be carried out not only along positive, but also along negative, lines. Certain subtle, insidious conditions must be eradicated. The mania for advertisements is deeply rooted and

backed by powerful interests. I believe it is among the most serious of all existing evils. The deleterious effects of the dreadful lettering, the God-awful colours, the vulgar drawing of the display signs, can hardly be overestimated. Even worse are the electric puerilities that make night hideous in our cities.

The control of all this lies in the hands of the public. If there could be founded a league of sufficiently powerful numbers, which would agree to patronize such firms or goods of which the display signs are artistic, it might be possible to substitute very quickly for the competition in vulgarity which at present exists a competition in loveliness. A beginning in this direction has already been made; certain posters produced in recent years are distinctly works of art. The Italian Renaissance gives a hint of what might be possible. In those days the state felt it necessary to advertise the fate which awaited conspirators and malefactors by hanging up in public places the bodies of those who had been executed. Pisanello's fresco at S. Anastasia gives a vivid idea of the practical workings of this custom, which must have been almost as unpleasant as our modern commercial advertisements. Art, however, was

soon called to the rescue; the disintegrating and putrefying bodies were supplanted by paintings of corpses by artists. Castagno, Botticelli, Leonardo da Vinci through their genius raised the motive of the *impiccati* to the highest artistic level. It was found that their masterpieces attracted more attention than rotting bodies had ever done, and thus was served not only the cause of art, but also the practical one of publicity.

At all events, as the public becomes educated in art, the present style of advertisement must come to an automatic end. It depends for its existence upon the power of the ugly to strike the untrained eye and attention. It is not the sight of ugliness but of beauty which haunts the memory of a person whose eyes have been opened. No one would be quicker to realize this psychological fact than the advertisers. Imagine the difference in our cities, in our lives, if each advertisement were a work of art. What an outlet for decoration and artistic expression might be found!

The mass of the people must no longer be divorced from art. The fact that the majority has no comprehension of beauty is the reason that ugliness surrounds us on all sides. And this ugliness in turn degrades the people still further. It is because art is patronized

chiefly by the wealthy that it has lost both its
intellectual character and its sincerity. Like
Christian Science, it is often made merely a
sauce of spirituality, served at the table of the
idle rich, to whet jaded appetites for the feast
of materialism. Thus has come about the
undue influence wielded by dealers. Our
ignorant rich often learn the little they know
from this usually uncultivated class whose
interests are apt to lie more in the direction
of mystification and obscuritanism than of
instruction and truth. The most elaborate
hocus-pocus is practised, especially in the
more costly Fifth Avenue shops, to impress
customers with their own ignorance and foster
a belief in the importance and pretended eru-
dition of the dealer. The ritual of certain of
these establishments is delightfully reminis-
cent of that of the medical profession in the
seventeenth century as satirized by Molière
or Le Sage. By lackies in gold braid, cere-
monial worthy of a court, elaborate fittings,
an impressive manner, technical terms, the
names of great clients skilfully dropped, the
dealer browbeats our millionaires into paying
many times what an article of the same merit
would fetch elsewhere. That the purchaser is
cheated, is less a matter for regret than that the
unintellectual and commercial dealer should

play this large part in forming the taste of the nation. He sets the fashion in antiques according to the supply and prospects of profit, just as the Paris dressmaker sets the styles in women's clothing. Even objects of great intrinsic beauty lose their power to inspire when dragged through this slough of commercialism and fashion.

The fact that art has been the prerogative of the wealthy has also been responsible for the importance assumed by the hotel in modern decoration. The opening of each important new caravansary in New York has marked a period of architectural style. After the Ritz we had an epoch of Adam; after the Biltmore, an era of Sloane. Nothing to as great an extent as the hotel has fostered the American love of new paint and varnish. In this the architecture of the twentieth century has sunk even lower than that of the nineteenth. Compared with our modern hotels, the mediæval exteriors and wholly evil interiors of Richardson appear models of refinement and even of intellectuality, and the influence of the psuedo-Romanesque was certainly less baneful.

The art of appreciating art is, therefore, not merely the passive occupation which it seems. It is in a very large measure creative

[198]

also. He who appreciates art, creates art by causing a demand which inevitably by some means or other will be satisfied. If the public appreciates the best in art, the best will be produced by the artists. The task of the teacher and the critic is after all not so mean a one. To teach our people to enjoy art will be a long task, a difficult task. Many battles will have to be fought and many enemies — enemies powerful and entrenched behind earthworks of social position and wealth — overcome. The final result, however, I firmly believe is not open to doubt. The great forces in human destiny are above the individual, above accident. The Renaissance would inevitably have blossomed in Italy, even had Brunelleschi never been born. The Renaissance would inevitably have swept into France, even had no French king ever set foot south of the Alps. The war of 1914 may be the spark which will kindle the art-hating *Kultur* of the nineteenth century, but the structure was already doomed. There had come a tide in the affairs of men, and waters which had been receding for long centuries had even before the war turned and begun to advance. It seems certain that they must continue to rise with ever-increasing force until the hated materialism, individual-

ism and Philistinism of the nineteenth century are forever washed away by a new art which shall be at once nation-wide and — *intellectual!*

www.ingramcontent.com/pod-product-compliance
Lightning Source LLC
LaVergne TN
LVHW012203040326
832903LV00003B/95